HOUSE KEYS
NOT
HANDCUFFS

Homeless Organizing,
Art and Politics in
San Francisco and Beyond

Western Regional Advocacy Project
2940 16th Street, Suite 200-2
San Francisco, CA 94103
www.wraphome.org

Western Regional Advocacy Project exists to expose and eliminate the root causes of Civil and Human Rights abuses of people experiencing poverty and homelessness in our communities.

Member Organizations

Los Angeles Community Action Network
838 E. 6th Street,
Los Angeles, CA 90021
www.cangress.org

Sisters Of The Road
133 NW Sixth Avenue,
Portland Oregon 97209
www.sistersoftheroad.org

Sacramento Homeless
Organizing Committee
1321 North C Street,
Sacramento CA. 95812
www.sacshoc.org

St. Mary's Center
925 Brockhurst Street,
Oakland CA. 94608
www.stmaryscenter.org

Denver Homeless Out Loud
2260 California Street
Denver, Colorado 80205
www.denverhomelessoutloud.org

Street Roots
211 NW Davis Street,
Portland Oregon 97209
www.streetroots.org

Coalition on Homelessness
468 Turk Street,
San Francisco CA. 94102
www.coh.org

Right 2 Survive
2249 E Burnside,
Portland, OR 97214
www.right2survive.wordpress.com

Street Spirit (AFSC)
65 Ninth Street,
San Francisco CA. 94103
www.thestreetspirit.org

HOUSE KEYS NOT HANDCUFFS

Homeless Organizing, Art and Politics in San Francisco and Beyond

Paul Boden

with essays by Art Hazelwood and Bob Prentice

This book is published to support the organizing work of the Western Regional Advocacy Project

FREEDOM VOICES

Library of Congress Cataloging-in-Publication Data
Boden, Paul.
 House keys not handcuffs : homeless organizing, art and politics in San Francisco and beyond / Paul Boden ; with essays by Art Hazelwood and Bob Prentice.
 pages cm
 ISBN 978-0-915117-24-6
1. Homelessness--California--San Francisco. 2. Homeless persons--Services for--California--San Francisco. 3. Housing policy--California--San Francisco--Citizen participation. 4. Community leadership--California--San Francisco. 5. Community development--California--San Francisco. I. Title.
HV4506.S355B63 2015
362.5'920979461--dc23
 2014039141

Freedom Voices
P.O. Box 423115
San Francisco, CA 94142
www.freedomvoices.org

Art Selection and Captions: Paul Boden and Art Hazelwood
Design: Jos Sances and Art Hazelwood
Editing: Marlene Griffith and Sally Ooms

Front Cover:
Ronnie Goodman, detail from *Dignity Without Bigotry*, 2013, Linocut Print, 24 x 18", Courtesy of the Artist

Back Cover:
Tarp Tour Protest, 2011, Photograph, Courtesy of WRAP

Contents
House Keys Not Handcuffs

This book is published standing on the shoulders of, and dedicated to, our friends

Arnett Watson
A woman with love for the whole community who asked for nothing in return and gave simply to keep her own spirit alive.

Mikey Chapman
He lived by a code of honor, the kind of honor that outlaws and outliers hold, where no written contract is needed, and a person's word is true. He lived this with a loyal, unshakable faith for those he trusted, those who lived outside the bounds of "normal" society.

San Francisco Print Collective, *House Keys Not Handcuffs*, 2010, Screenprint, 23 x 17 1/2", Courtesy of San Francisco Print Collective

WRAP uses the phrase House Keys Not Handcuffs as a rallying cry. It connects in a few words the struggle against the criminalization of people forced to live in our streets and the struggle for housing for all. The SFPC created this bold image that stands out on protest placards with a clear message.

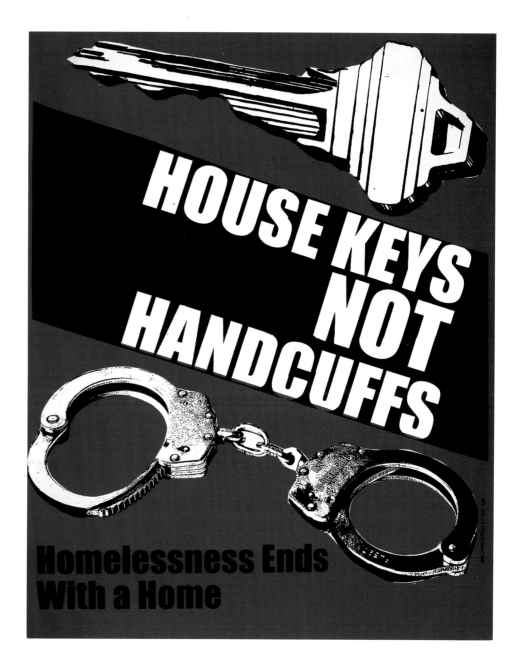

Thanks

In all ways this book is a group effort. From the organizing we write about to the artwork and articles we re-publish. None of that exists without everyone who was involved. This book honoring that organizing though, owes much of its existence to the hard work and commitment of the people we would like to acknowledge here: Jenny Friedenbach for content and advice, Jeff Kositsky who raised the funds for publication, Ruth Pleaner who kept the whole project together, Sally Ooms for writing and copyediting, Ben Terrall for proofreading and WRAP editor Marlene Griffith who, as always, made sure our writing is in our own words yet clear and articulate.

The Western Regional Advocacy Project is very grateful for the generosity of friends and allies who made it possible to print this book. These include organizations such as the Coalition on Homelessness, Community Housing Partnership, Episcopal Community Services, Hospitality House, Tenderloin Neighborhood Development Corporation and Spotlight Design and Printing.

We are proud to say this is the second print run of our book and again express our gratitude to friends and allies who helped make this happen: Ahmed Alkhatib, Friedman Family Foundation, Hospitality House (again!!), Jessica Bartholow, Kristina Boden, Lydia Ely, National Health Care for the Homeless Council, Swords To Plowshares and UNITE HERE Local 2.

Preface

House Keys Not Handcuffs is a reflection on over 30 years of homeless organizing in San Francisco. It is an attempt to sort out what went well and what went not-so-well as a community began to organize in order to hold public and private institutions accountable. Its purpose is not only to distill the lessons we have learned, but to encourage others to document and reflect on their own experiences in the hope that we can collectively contribute to a stronger, more broadly-based movement.

House Keys Not Handcuffs draws from the insights of Paul Boden, whose own experiences – on the street and as activist, as cofounder both of the Coalition on Homelessness and later the Western Regional Advocacy Project (WRAP) give him a unique and wide perspective. History is often written from the point of view of those with power and privilege. *House Keys Not Handcuffs* is a voice for people who have no power or privilege except for their capacity to organize and demand social justice.

The book is supplemented by two essays offering additional perspectives on the last three decades. *We Won't Be Made Invisible: Art of Homeless Activism* by Art Hazelwood documents the growing influence of art in homeless community organizing. The artwork in this book highlights a wide range of approaches to the struggle, from cartoons to street posters. As artist and activist, Art has contributed work to the Coalition on Homelessness since 1994 and has been "Minister of Culture" for WRAP since its inception. He was also author and curator of *Hobos to Street People: Artists' Responses to Homelessness from the New Deal to the Present*, which chronicles the ways in which art became an integral part of organizing culture and strategy. *Homeless Organizing and City Policy* by Bob Prentice considers the ways in which homeless activism has influenced public policies over the last three decades. Bob was director of homeless programs for the San Francisco Department of Public Health during the first decade covered in *House Keys Not Handcuffs,* with lead responsibility for city homeless policy and lead author of *Beyond Shelter: A Homeless Plan for San Francisco* during the administration of Mayor Art Agnos. These essays are complemented by articles dating from the early days of the Coalition on Homelessness to the present. They give the reader "live time" perspectives of the events described as they occurred.

Homelessness is a visible manifestation of a society that is lacking in justice. We offer *House Keys Not Handcuffs* in the hope that it will help re-invigorate a social justice movement in this country that respects all of us as human beings and ensures that all people have a right to exist and a place to live as basic human rights.

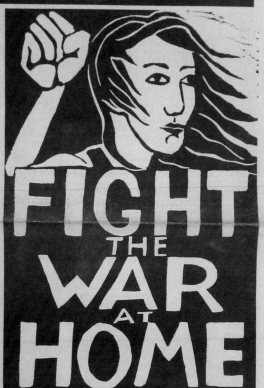

STREET SHEET $1 DONATION

A PUBLICATION OF THE COALITION ON HOMELESSNESS
SAN FRANCISCO

FEBRUARY 1991

TRANSITION TO WHERE?
The Lack of Homeless Housing

As this nation pumps $2 billion a day into the desert sands of the Persian Gulf, the lack of low-income housing keeps thousands of people trapped in San Francisco's shelter system.

The cover story of January's *Street Sheet* offered an historical analysis of San Francisco's emergency response to homelessness to put into perspective the Multi-Service Centers (MSCs) opened by the City in July 1990. The Agnos administration has depicted these MSCs as solving homelessness by providing a link, previously missing, to transition people off the streets.

To summarize the points made in last month's article, the MSCs *are* an expansion of the City's existing shelter system; they do *not* represent a solution to homelessness. Calling the MSCs — or any program that purports to "transition" people — a solution assumes that there are adequate housing options to transition people into that will allow them to stay off the streets. It also assumes that once those who are currently homeless are properly transitioned, that no others will become homeless. Calling the MSCs a solution implies that San Francisco has no housing problems and no one is at risk of becoming homeless — that homelessness is caused by a lack of social workers, not lack of affordable housing.

But people do not leave shelters with high-paying permanent jobs and wads of cash in the bank, nor do they transition into rent-free apartments. A comparison of the numbers of homeless people and public assistance levels in San Francisco, with the costs of housing, demonstrates the grim realities facing people who are being expected to transition from homeless to housed, and of the equally grim reality of tens of thousands of San Franciscans living on the edge of homelessness.

Housing Costs and Incomes in San Francisco

According to City estimates in *Beyond Shelter: A Homeless Plan for San Francisco*, there were 6,500 homeless people in 1989 on any given night. The research group HomeBase found a higher number: based on applications for emergency housing assistance to government agencies, at least 23,000 people were homeless in San Francisco in 1989.

As of January 1991, approximately 10,000 people received $341/month in General Assistance grants. Another 22,000 receive an average of $650/month in disability (SSI/SSA) payments. Another 12,000 families received an average of $694/month in AFDC payments. By definition, people have negligible savings at the time they apply for public assistance. The City's Residence Element, completed in July 1990, found that there are 49,000 households (approximately 100,000 individuals)

whose income is less than $10,000/year ($833/month), which is 25% of the City's median household income.

Is there sufficient housing in San Francisco affordable to these 100,000 people, including public assistance recipients, and the 23,000 who are homeless and expected to "transition"? The HUD definition of affordability is that a person pays no more than one-third of their income in rent. When people have no savings and pay more than 33% of their income in rent, they are at risk of losing their housing at the briefest interruption of their income.

So What IS Available?

GA recipients may obtain Single-Room Occupancy (SRO) units at below-market rates in for-profit hotels through the Modified Payments Program (MPP), at an average rent of $260/month, or 75% of their income.

What about the City's subsidized "affordable" housing? The vacancy rate for habitable units in the City's Housing Authority projects and non-profit-managed affordable housing is less than 1%. In the same year that *Beyond Shelter* estimated there were 6,500 homeless people, only 55 new units of subsidized very low-income housing were created, and even

Figure 2
Street Sheet, February 1991, cover art: **Eliza Miller,** *Fight the War at Home*, 1991, Linocut Print, 9 x 6", Courtesy of Coalition on Homelessness

This print, published during the first Gulf War, became an early defining image of the COH and exemplified its ongoing effort to change the public discussion of homelessness into a framework of social justice.

Street Sheet was founded in 1989 and is the oldest continuously published street paper in the country. The paper is distributed by vendors as a dignified alternative to panhandling. The first editor, Lydia Ely, sought artists who could give visual form to the struggles of homelessness. She turned to a friend from Washington DC, Eliza Miller, who created iconic and expressive woodcuts that came to define the bold look of much of the artwork of the paper.

HOMELESS ORGANIZING
Art and Politics in San Francisco and Beyond

Paul Boden

There is no such thing as a single-issue struggle, because we do not live single-issue lives.

<div align="right">Audre Lorde</div>

There really is nothing quite like that feeling you get in the pit of your stomach when you realize, "Holy shit, it is time to go home and I got no where to go." Definitely your life changes big time, but unlike the current mainstream discussion, you don't automatically become deranged, dysfunctional, pathetic or criminal. Many of us got pissed off at our situation and lucky ones (like me) learned what community really means and how powerful a community can be when mutual respect and appreciation are the cornerstones of your community organizing campaigns.

Thirty years ago, just out of my teens, I hit the Tenderloin in San Francisco with nowhere to go. I got incredibly lucky and connected with people who made up an institution called Hospitality House. There I was not only encouraged but also expected to become part of a community of people and organizations who operated in the spirit of social justice. They did everything they could to help their community members and their neighbors exist in what was then a very recent phenomenon we were calling homelessness.

So, at Hospitality House a space was created for a group of us to work in, a space for homeless people to help out other homeless people. We gave referrals, let people use the phone, sit down, use the bathrooms. We did whatever we could, which wasn't very much, but from 7 a.m. to 11 p.m. it became a drop-in center and a safe place to get out of the rain. From 11:30 p.m. to 7 a.m. it became a crash pad for our neighbors who no longer had a place to sleep.

By creating this space, those of us who had been in the same situation and who were a little freaked out, angry and scared, learned to get over ourselves and understand the value of "what goes around comes around."

My first big lesson was how everyone benefited by helping out neighbors when they needed it. I worked at Hospitality House for three years and eventually moved to a mental health agency where I became a supervisor of a hotel that provided supportive housing for 58 mentally ill homeless people.

The experience of going from Hospitality House to a mental health agency, from being a young man recently off the street to becoming a supervisor at literally double the pay, was also my first revelation of white privilege. I had grown up on Long Island and had a much better baseline education than 90 percent of the people I hung out with. As a white male, I was able to make the transition from client to staff and from front line staff to management—primarily because of where I was born and the color of my skin.

Here, I also learned my second big lesson: the power of funding, and with it the dangerous and scary practice of divide and conquer and the mindset of us versus them.

Unlike Hospitality House, this new agency was 100 percent funded by the City of San Francisco, and so it was beholden to the City. I learned that once government provides the funds, government dictates what help you are expected to give, who you are expected to serve, what criteria you need to use to screen people out, and what kind of label has to be attached to your community members and your neighbors for you as a community to help them.

At that time, I was also working and organizing with the North of Market Homeless Task Force and other local community groups that were often critical of City actions, and I spoke up at community forums. Within a year, I was given an ultimatum from the executive director. To continue my employment, the director demanded (in writing) I show him the agenda for every forum or

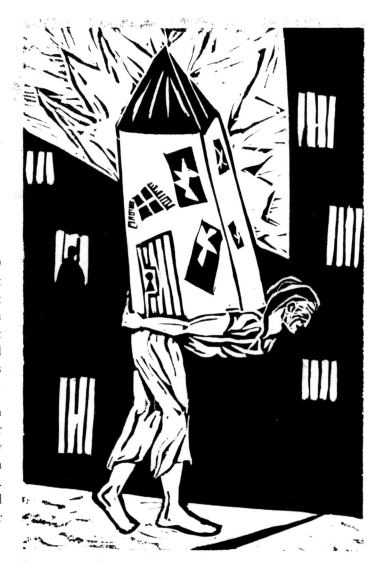

Figure 3
Eliza Miller, untitled, 1992, Linocut Print, 9 x 6", Courtesy of the Artist

This image, used as a cover of the *Street Sheet*, expresses simply and boldly the divide between those housed and those on the street who are forced to carry all their possessions with them. For people without a house, everything that you call home is reduced to what you can carry in a shopping cart or on your back.

Figure 4

Tom McCarthy, *Homeless Veterans*, 1991, Ink on Paper, 6 1/2 x 6", Courtesy of Coalition on Homelessness

The end of the Gulf War brought home a new wave of veterans and renewed the endless discussion of what becomes of returning vets with physical and psychological wounds as they navigate the maze of trying to access support.

McCarthy's cartoon might have seemed hyperbole to those waving the flag of victory before the long-term effects of that war and its characteristic Gulf War Syndrome became known.

McCarthy was a cartoonist with the *Tenderloin Times*, a neighborhood paper published by Hospitality House. He was a regular contributor of cartoons to the *Street Sheet*.

meeting I was going to so he could tell me how I should respond. I could not be in a newspaper or on TV without prior authorization from him.

As this agency hoped would happen, I left. I returned to Hospitality House where a whole bunch of us began creating the Coalition on Homelessness, part of the story I tell later in this book.

The purpose of this book is to show how accountable organizing comes from the community, how it embraces and represents its community with integrity. Accountable organizing can unite disparate peoples and groups— faith-based folks and atheists, artists and accountants, researchers and theater people. The main thing is we all approach our work through the lens of social justice. That is how we can achieve power.

In past decades there have been way too many ten-year plans and other politically-initiated programs that obfuscate the government's responsibility, and too many people "advocating for" or "studying" other people's homelessness and poverty who

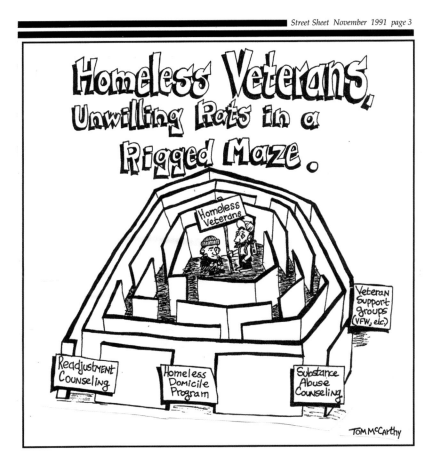

13

are woefully removed from the actual experience of homelessness.

What follows speaks for those of us who were involved in the work of organizing, who were actually there. If people who were involved don't see themselves mentioned or any organization part of these efforts doesn't see itself recognized, it is not because their contributions weren't meaningful or appreciated. It is primarily because, unfortunately, we waited 30 years to go back through our history and to attempt to record it. And, we are doing this in an environment where there is no central data bank.

I guess we call that the first lesson in this book. If one day you think you might want to document your experiences for others to learn from, you might think about recording and storing them in a place you can access later.

Beginnings

The San Francisco homeless program officially started in October 1982. That winter had historically high levels of rain and historically low temperatures. The fact that so many community members were suddenly finding themselves without housing created a sense of urgency that permeated local government, community organizations, churches and the media. It was, "Holy shit. We have a crisis on our hands."

And in a sense the response was really beautiful—that it wasn't homeless people's problem; it wasn't homeless

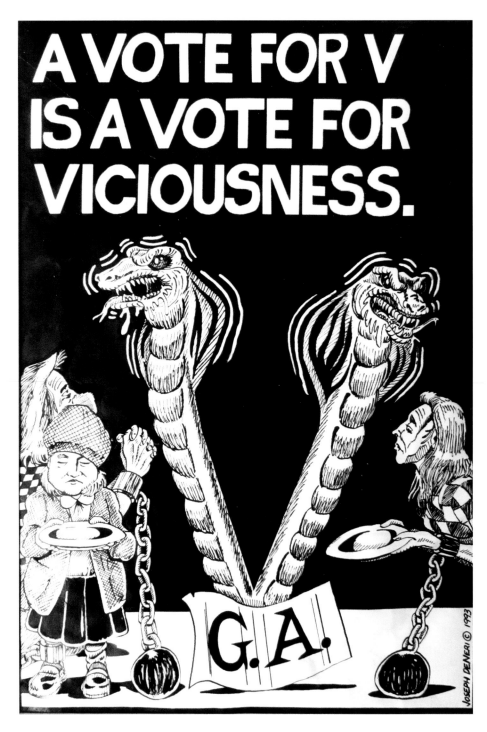

Figure 5
Joseph DeNeri, *A Vote for V...*, 1993, Ink on Paper, 21 x 16", Courtesy of Coalition on Homelessness

Proposition V was put on the ballot by former police chief, Mayor Frank Jordan, shortly after he was elected to office on a campaign to remove homeless people from public spaces in a police program called Matrix. He then used the next election cycle to put Prop V on the ballot and go after poor people in general. The measure claimed that fraud was rampant and that a costly system of fingerprinting and proof of residency was needed for General Assistance applicants. The measure passed. Attacking homeless and poor people had clearly become a local politician's wet dream en route to getting elected or passing a ballot measure.

This poster was created by Joseph DeNeri for one of several proposition campaigns the COH was involved in against Jordan and his business cronies' onslaught against poor people.

people's fault; it was that our community had a serious problem on our hands and we all needed to come together and address it.

The downside of this crisis was that the emergency response activated what was supposed to be a short-term emergency solution. The whole shelter system was opened immediately but was identified as a temporary program, in spite of the fact that state cuts to residential and community-based treatment for indigent, mentally-ill community members and a good four years of massive federal cuts to America's affordable housing program have created neither out-of-the-blue nor temporary crises. These cuts were deliberate. They were systemic and, as we see 30 years later, they sure as hell have been permanent.

It was a classic example of the road to hell being paved with good intentions. This is not said to point fingers at anyone, especially by someone like me who was out there in the streets screaming and yelling for, and getting, food, clothing and shelter. But sure as hell, that's all we got—food, clothing and shelter.

So, through 1983 a gathering of church-based and community groups, and community-based service providers like Hospitality House and St. Anthony's were pushing the City, demanding the City be accountable to the needs of community members and provide an alternative to the families and the seniors and the disabled people and all of us who were suddenly finding ourselves with nowhere to go at night. Remember, at this time homeless programs per se did not exist.

We created intake sheets, set up referral systems, and organizations began using gym spaces and drop-in centers and churches that neighborhood residents had been using for recreation and food programs. Groups converted spaces where people had been eating, with cots or mats put out on the floor—to crash pads. Churches that had been around for hundreds of years in San Francisco opened their doors at night so people could sleep in their pews. All the while, we were holding community forums demanding that representatives of the Mayor's Office come meet with us and get engaged in responding to the crisis we saw in front of us (see *McKinney-Vento Turns 25* page 100).

Mayor's Blue Ribbon Task Force
In 1987, the Mayor formed the Blue Ribbon Task Force on Homelessness. Unfortunately, forming task forces or coordinating bodies or inter-agency councils has become the standard government response to addressing homelessness and poverty. There's an old adage that when government wants to kill an issue instead of addressing it, it forms a committee or a task force.

With the Blue Ribbon Task Force came an amazing transformation. Rather than San Francisco saying, " Yes, we have a problem. What are we all going to do about it?"

the City said, "We have a problem. Here are a couple of thousand a year from us to you. Go fix it. Go establish a referral system, an emergency shelter system, a service system. Now it's your problem."

So instead of you holding government accountable to address poverty and homelessness in the city, now government is going to hold you accountable to document how you are spending the money they give you—to validate who it is you are serving, what you are doing with the money and how you are fixing the homeless people so they can fit back into society.

This profound reversal has become the major governmental response at all levels for addressing homelessness: government has no responsibility other than to create competitive funding streams, to mandate often asinine and useless reporting procedures and requirements, to institutionalize a system that nobody ever wanted to see created in the first place and, in doing this, to completely and totally relieve itself of any responsibility for creating the situation or having any role in fixing it (see *Learning From Our Past* page 77).

Them and Us

One of the first signs of the impact of this rather malicious transfer of responsibility was the glaring separation created between community members who were homeless and poor and the community organizations that had been united in calling for a response to the advent of growing homelessness.

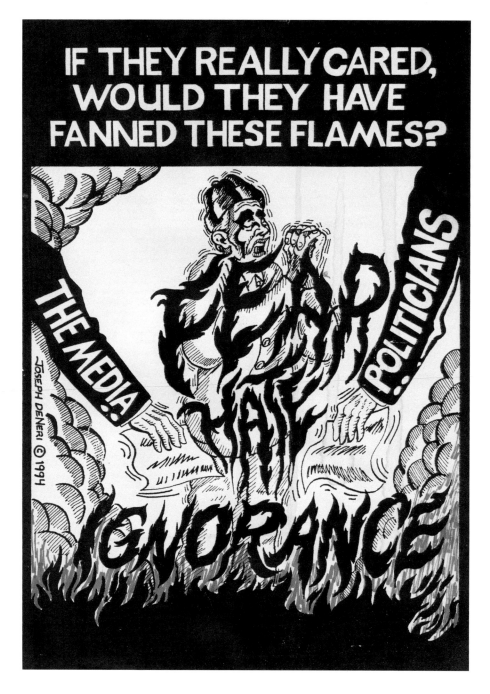

As soon as the City started funding community groups to provide services such as shelter, food and clothing, the term "Service Provider" became a major part of the homeless lingo. The City wanted to meet with *only* the Service Providers Network to hold them accountable—to the politicians, not to the entire community. This tactic personified the divisions taking place in our community and created the need for separate forums and meetings. Shelter staff met among themselves. Homeless people met among themselves. They had become clients and people seeking services, no longer a vital component in the campaign to eliminate and address the issue of homelessness, no longer considered part of the solution, no longer part of "us." They became "them."

The City was now telling service providers, "Because we're paying you by the head, we don't trust you to tell us how many people are sleeping out on the street or in the open. From now on, you are required as part of your funding obligation to do separate intakes for each person asking for an emergency shelter bed." The whole system of screening and intake was established solely based on funding, not based on need.

Before that requirement, if there was a bed available, you got a bed. If there wasn't, you didn't. Nobody asked for a social security number. Nobody asked for your date of birth or your immigration status or, like nowadays, even your fingerprints. They didn't require any of the other criteria routinely expected of "clients" today because frankly, and I'm telling you as one community member to another, nobody needed to know that shit. If you needed a bed and had no place to sleep, you got the bed. Very simple, very humane, very direct.

The intake criteria imposed on service providers once the City started giving them money left them with only two choices: either capitulate to the demands of their funding source, the City, or sacrifice that funding source and risk no longer being able to meet the need so readily apparent in their community.

The power dynamics behind this cannot be overstated.

The rules change when a city takes the unified voice of a community and, through funding, divides it up between those who are on "my side," meaning the mayor and the city providing funding, versus the service providers, organizers and homeless people who may be saying what a mayor does not want to hear. City hall then dictates how we approach homelessness. Service providers who will do their bidding get the funding. Those organizations and people who are saying what the mayor may not want to hear get left out.

The Need – Lack of Affordable Housing

It was very early in the process when those of us living and working in the community knew emergency shelters were not the answer. In a short-term immediate crisis, shelters have been an effective respite from a crisis situation. But we knew that an emergency shelter system in and of itself wasn't going to end homelessness.

It was lack of affordable housing that created homelessness, not the lack of emergency shelters. And it didn't take us more than five minutes to figure that out. Therefore, there was no legitimate need to professionalize and institutionalize the provision of emergency shelters.

Shortly after the City of San Francisco started funding the shelter system and sweeping homeless encampments, the City suddenly required reporting documentation and other

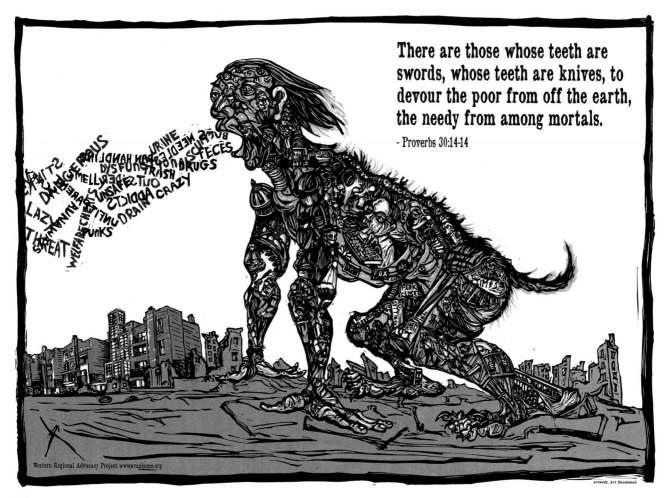

There are those whose teeth are swords, whose teeth are knives, to devour the poor from off the earth, the needy from among mortals.

- Proverbs 30:14-14

bureaucratic data—"intake information" like date of birth, social security number, and whether people fit ever-changing definitions of homelessness—to justify the funding. Volunteers and homeless people who had implemented the shelter programs were no longer deemed qualified to work in them. They were no longer a part of the solution. Instead they became labeled as outliers and dysfunctional.

Thus began a whole different focus on what it was we needed to do to address the crisis of homelessness. When we began, we knew we needed to come together, take care of the immediate needs of our brothers and sisters while we pushed the local, state and federal governments to understand that their neglect had created a crisis in our community.

But 30 years later, we still have a shelter system built around the idea that the mayor has a homeless program and the professional institutions that are "experts" on the

Figure 7
Art Hazelwood, *Beast of Hatred - Those Whose Teeth are Swords*, 2007, Offset Print, 17 1/2 x 24", Courtesy of WRAP

The combined forces of attacks by media, public officials, police sweeps, private security zones, forced busing out of town, and vigilante violence make up the body of the beast that spits hate, as portrayed in this poster created for WRAP.

Figure 8
Jos Sances, *Reagan Comes Home to Roost, Mourning in America*, 2011, Screenprint, 16 x 16" Courtesy of the Artist

The title of this print tells the whole story. The policies adopted under Ronald Reagan's presidency have led to a series of economic disasters that began with the poorest and continue up the economic ladder to the hollowed out middle class. Reagan is portrayed as a vulture that hovers over a home people USED to live in.

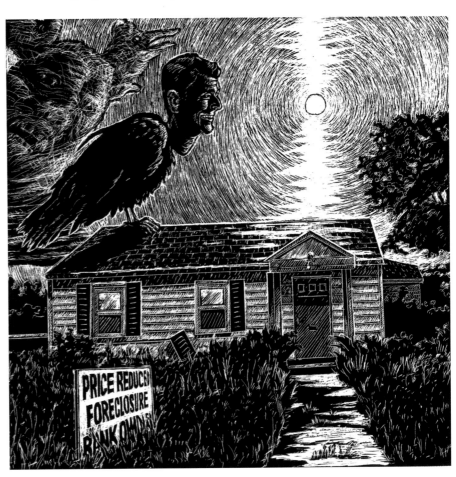

19

issue have set up a system to "fix it." All changes have to go through a bureaucratic process that is ever more distant from the people whom it is designed to serve. Even as recently as 2014, the Coalition on Homelessness in San Francisco had to embark on a major campaign to persuade the City to make access to the emergency shelter system easier and to increase the length of stay.

When those of us in San Francisco saw this pattern developing, we only had to look as far as our welfare program, our public housing program, the Economic Opportunity Commission or the War on Poverty programs to see what happens when the lives and the experiences of poor people are relegated to the level of clients (see *Paul Boden and the History of Modern Day Homelessness...* page 101).

Creation of a Mutual Distrust Society

Few people distrust welfare recipients as much as welfare workers and vice-versa. Few distrust public housing recipients as much as public housing workers. Frustrated with the bureaucracy, they are trained to screen their clients, trained to deny people in case they are cheating, and so a mutual distrust ensues between clients and staff.

These workers' frustration and distrust based on documentation requirements, based on service criteria, based on validation of the needs of the very people they were intended to serve, make it easy for the federal government to dismantle or defund those systems. As with every other community, San Francisco has lost millions of dollars yearly in federal affordable housing money. Mistrust also makes it easy for the "clients" of those systems to become demonized and dehumanized.

This is how we ended up with today's San Francisco homeless program and how the social welfare, health care and housing systems became systems of institutionalized bureaucracies serving at the pleasure of whoever happened to be in office at the time.

Consequences of Them versus Us

Once homeless people, community service providers and the City began to distrust and see each other as "them" and not "us," the well-intended responses to homelessness in our community were destroyed.

By 1987, we said, "OK. We see the train and it's left the station." Staff members who had been engaged for years were no longer qualified to work as service providers. Professional poverty organizations were coming into the game as either city or self-identified experts on homelessness, and we saw what the end result was going to be. So we created the Coalition on Homelessness (COH), determined that we would never allow it to fall into the realm of the divide and conquer scenario that we saw clearly would weaken all of us.

IT WAS LACK OF AFFORDABLE HOUSING THAT CREATED HOMELESSNESS, NOT THE LACK OF EMERGENCY SHELTERS.

"Better keep moving, I hear they'll be taking **US** away next..."

Figure 9
Tony Taliaferro, *Better Keep Moving*, 1999, Ink on Paper, 9 3/4 x 7 3/4", Courtesy of Coalition on Homelessness

Tony Taliferro created several cartoons for *Street Sheet*, including this one addressing the ever increasing proliferation of laws aimed at removing the presence of poor and homeless people for "crimes" such as sitting, sleeping, standing still and blocking sidewalks.

The Coalition on Homelessness

We formed the Coalition to bring together community organizations and homeless people to develop an organizing effort with equal representation and equal decision-making power, priority setting power and input on program design. We hoped to get frontline service providers who served poor and homeless people and the poor and homeless people themselves to recognize that their experiences in the institutionalized bureaucracies on which they both depend have way more in common than they are unique and understand the only way they were going to be able to bring about change was by working together.

At its heart, the Coalition is grounded in the belief that the power to change anything in our world that we feel should be different has to come from within. While we all came from the world of homelessness, what was within each of us was a heartfelt commitment to social justice. You can't use charity as a substitute for change. You can't use bureaucracy as a substitute to fulfill a need, and you can't do things strictly for others. To be meaningful, change has to be owned and created by the people who

are most affected or directly being hurt by what currently exists. In this way, we all benefit (see *At Our Core* page 80).

Philosophy

We created a board of directors who personified our goal of uniting by giving equal representation to the Service Provider Network and the group of homeless people called the Homeless Caucus. Several years later, when we created the Community Housing Partnership, we gave equal representation to homeless communities and the housing development community.

The most important aspect of this was that everyone involved—all the organizations, all the individuals—recognized that bringing together our skill sets and our individual communities made us stronger and smarter, even if those involved didn't see the homeless people as their primary target population.

Ongoing Outreach

To ensure the Coalition would stay a part of the homeless community and accountable to that community over the long term, we set about creating our own internal system of outreach—a process of having direct face-to-face contact with homeless and poor people, including those who might not choose to attend Coalition work group meetings or volunteer at the office. We developed a list of questions for each outreach cycle to guide our work. We asked each person the same questions.

STREET SHEET
THE NEWSLETTER OF THE COALITION ON HOMELESSNESS, SF

July 1990

THE DISAPPEARED

During the week America celebrated its 214 years of independence as a bastion of freedom, San Francisco took away another freedom of choice from homeless people, and made homelessness a crime.

Homeless people, like blacks before the Civil Rights Era, seem to be losing more rights and gaining more restrictions on their behavior and movement in our society, and particularly in our city.

In San Francisco, as in Santa Cruz, San Jose, Oakland, Sausalito, and about 10 other California cities, a public backlash against homelessness is being reflected in city bans directed specifically against homeless people.

Our Mayor caved in to the growing conservative backlash of anger and fear against the ever-increasing numbers of homeless people seen in our streets and parks by enforcing the sleeping ban in all our parks. He also massaged, manipulated, and managed the media to accept that everyone would be given a "decent and humane alternative."

Media Manipulation

What the Mayor offered to homeless people and the disenchanted general public was two "Multi-Service Centers" (MSCs). In reality, these consisted of nothing more than 110 beds 18 inches apart for single men at the Fifth and Bryant MSC South of Market, and only a few male beds available at the Polk and Geary MSC North of Market for the more than 1800 people who, according to the Mayor's own Homeless Master Plan, are forced to live in the streets, doorways, and parks nightly. The Mayor convinced the media that these MSCs would be an answer — that they would provide direct access to much-needed medical, substance abuse, and mental health treatment, as well as job developers, affordable housing specialists, and legal and entitlement advocates from the community.

In fact, once again, all that was really available was 110 shelter beds. This happened because the Mayor decided to force his plan into action before all of the critical services were in place, and back it up with police action.

All that has been accomplished in the week after Art's action has been a disappearance of homeless people from Civic Center Plaza and a criminalization of homelessness.

This uniform outreach process reflects our priorities and makes it easy to identify the common issues through responses of not just one or two people, but the majority of the people we speak to. When the Coalition does 100 outreaches and 90 percent of the people we talk to say "the cops are fucking with us," then Coalition work groups and staff need to work from that position with their research, writing and organizing. This guarantees a community priority, drives the work and ensures the

Figure 10
Street Sheet, July 1990, cover art: **Eliza Miller,** untitled, 1990, Linocut Print, artwork size unknown, Courtesy of Coalition on Homelessness

Even as early as 1990, people were desensitized to the word "sweep." The Coalition used artwork to give a visceral sense to what it means to be criminalized for being homeless. As early as 1985, mayors had resorted to addressing homelessness by making homeless people disappear under the pretext of outreach when in fact they were using cops. The media line "we're helping them" had become standard by 1990. This image contradicts that story and says this is about cops and criminalization and not about helping anybody.

agenda does not come from the top down. It will always reflect the common refrain of the majority of the homeless people we talk to.

Due Process in Shelters

This outreach process resulted in one of the Coalition's first real systemic achievements: due process for people who were being kicked out of the emergency shelters. It was a direct response to a growing recognition that the shelter system was acting randomly in saying, "You can stay," or "You have to leave." When a father had a beer after his mechanic job, and the entire family, including a newborn baby, was put out on the streets, folks at the Coalition on Homelessness used that event to call for badly needed change. Shelters did not have to be accountable in those decisions and that power dynamic needed to be addressed. We pushed for and won a system of accountability that balanced the power between shelter residents and providers/City administrators. Shelter residents now not only have access to representation from advocates, but to an independent arbitrator whose decisions are binding as to whether they can keep their bed or not. We put an oversight body in place with majority seats going to homeless and formerly homeless people to ensure the procedure is being followed.

Street Papers

The Coalition also decided early on that, rather than simply complain about the way our issues were being addressed in the mainstream media, we needed to create our own forum for educating the public using our voice, our documentation, and (eventually) our artwork. In San Francisco, the paper is called *Street Sheet*. It started in 1989 and continues to this day.

Shortly after creating the paper, an organizer at the American Friends Service Committee contacted us about an East Bay edition. The Coalition assisted in bringing that together. But for the same reasons stated earlier about grounding any work we do in our community, everyone involved decided S*treet Spirit* would not be the Coalition's paper for the East Bay. It would be a paper of the East Bay for the East Bay.

Both papers are non-commercial publications, distributed to vendors for free to provide a legal and dignified alternative to panhandling in their communities. Cumulatively, the newspapers have provided over $10 million cash directly to the vendors and increased membership and support for the organizations. Because they are non-commercial, they are protected by California state law since "they are of no intrinsic value other than to communicate a message."

The simplicity of this model of not charging vendors and not selling ads also has protected both papers from police harassment under panhandling laws. In addition,

the papers' vendors are very low threshold individuals, that is, folks with severe impairments that prevent them from almost any other form of gainful employment. As vendors they are able to make a living, or supplement their very low incomes. Last, for the Coalition on Homelessness, the *Street Sheet* does far more than create income for destitute people and get our collective voice into the media. It generates donors for the organization. Simply put, *Street Sheet* enables all our social justice work to happen and to stay independent (see *Break the Blackout* page 78).

Local Responses, Local Solutions

This philosophy of creating community-based projects over the years has earned the Coalition a good reputation for working with local people to create their own local responses and solutions. Several times the Coalition served as an incubator for groups that needed a fiscal agent, assistance writing a grant or knowledge about how to deliver services. It has helped with program design and research, and helped to ground new programs in a spirit that reflected the experiences and the priorities of their local community.

Community-based projects always need to be owned by those who implement them. We never offered help by saying, "If this is what you want to do, here is what you need." Our approach was always a guide to outreach. This is how you verify the intended program meets the needs of the people you want to serve or matches the priorities of your community.

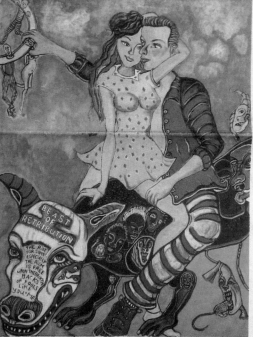

STREET SHEET
A PUBLICATION OF THE COALITION ON HOMELESSNESS
SAN FRANCISCO

SEPTEMBER 1995

THIS IS FOR BO

Someone whom I cared about recently committed suicide. She felt that there was no way out of the various holes she'd dug through her years. And, unable to think of anything sensible to do, she hung herself.

She did not have to end this way: we had talked many times in the last few months about how she could gain control of her life once more. I told her to use me an example — I had never spent the night at a friend's house until I was in my 20's, and I have just learned to write a check — but I had gotten tired of the situation. I eventually packed up my son, bought a bus ticket, and grew up at the age of 33.

"And look at what happened to you," she had wailed. "You ended up in a shelter!"

I think about this conversation now, because it makes me wonder how many people have either killed themselves, or allowed themselves to be killed by abusive spouses, because they did not want to start over — especially if the first step would have led to a shelter.

I do not understand this thinking; I am tired of hearing that shelters cater only to people wanting free rent, or that the only people in shelters are junkies and people who do not want to work. I owe my life to Harrison House in Berkeley. I wouldn't have admitted it then, and am loathe to mention some people's names even now, but Harrison House brought into my life some of the most important people I have ever known.

Until I went to Harrison, I had always been around the sort of people who had the same problems everybody else does, but God forbid, better not admit it. I went through my first 30 years believing there was absolutely no place for me on this earth. I had spent my life believ-

ing I was in this alone — as Bo did — and I found out, because of Harrison House, that I was wrong.

I suffered during my time as a shelter resident, sure. This was someone who had grown up with closets the size of most people's living rooms. The most difficult adjustment was getting used to the lack of privacy. I thought I

© *Jane "in Vain" Winkelman 1995*

would go crazy if I had to listen to my roommate's two year old screech and yowl through one more night; no one would have ever been able to tell me that, near the end of my stay, I would be sitting and rocking that same child.

Many times I thought I had made a mistake
continued page 2, column 1

CAR 54, WHERE ARE YOU???

Think for a minute how you would feel if someone was to pull out a gun and shoot at you and your friends, wounding two of you, and the response from your frantic call to 911 was a week long campaign criminalizing you. "These people are breaking the law," the Mayor says about you. You "undermine the safety and integrity of our parks and neighborhoods," he says.

But wait a second. You didn't shoot anyone. It wasn't you waving a gun around, nor was it you who shot the police officer or his dog.

Someone shoots you — you call 911 and somehow you discover that you are the criminal. You and "them" are the criminals; the cop and his dog, along with the homeowners forced to see you, are the victims. What happened to your call for help?

Unfortunately for you, the call was channeled through to the Mayor's office where Jordan's staff immediately went to work organizing a political campaign capitalizing on the tragic shooting incident. It's tragic that people were shot. It's tragic that an animal was killed (all life is precious). It's sick that City Hall has responded the way it has. And the media circus generated from this response is like an out-take from a Fellini movie.

Just as the 911 response from the California street shooting warranted Board of Supervisors hearings, so too does this response.

Just as you would expect to be accorded humane treatment as the victim of a shooting incident, so too should homeless people.

Mayor Jordan has sent a clear message to us all: if you are without housing, you are without police protection. Truly a no win situation—
continued page 2, column 2

This was not easy nor was it always successful. Unfortunately, there are also those entities or programs we helped create that have spun off and become very detached from their original intent. But over time, we learned from the mistakes we made, and programs developed through the Coalition process and belief system have continued to fulfill their intended mission.

An Example of Success

Perhaps one of the Coalition's biggest accomplishments, achieved through a four-year process working with the Council of Community Housing organizations, was the creation of the Community Housing Partnership, a permanent affordable housing developer that hires from within the community. It has always been our belief that with training, support and resources poor and homeless people can and will do for themselves and their community. While we had been able to prove that truism on small-scale projects such as staffing the Coalition or writing articles for the street papers, the development of affordable housing was perceived as beyond our ability. The Community Housing Partnership really put our beliefs into practice on a larger scale. (see *Pit Bull and More* page 88)

Close, But Not Quite

One Coalition work group created a center specifically designed to reduce the number of people dying on San Francisco's streets. Called the Homeless Death Prevention Project, it then became the McMillan Project and then basically a City program. It now no longer even exists while, as we all know, way too many people continue to die unnecessarily and alone on our streets.

By not ensuring the board of directors of this program was a community board of directors, the program shifted into a corporate, and then City bureaucratic, directorship. It got taken over. It shifted from low threshold (people with most obvious needs) access with no questions asked to a program with screening and intake criteria, forms and verifications. The program was conducted by City staff, who often used clients from the program in public relations vignettes for the Mayor's Office. It became an agent of bureaucracy rather than a program of compassion.

Working together

The Coalition's commitment to its original philosophy required us to put our egos aside—from writing the original concept paper and facilitating an intensive community process around program design and budget, to negotiating with the City and the federal government around opening up our first housing site. We learned to work with people who knew housing issues better than we did, who knew housing budgets better than we did, and most importantly, who were willing to work in partnership with our community (poor and homeless people) to create an organization of equals.

There is another plus to having an agenda based solely on community need and not on a political or social position. It lets the Coalition work with myriad organizations, either in partnership on particular projects or by providing technical assistance—or sometimes even just providing meeting space.

The fact that the only question the Coalition has to ask is "Are we representing our community?" meant we could work with organizations that usually didn't work well together. We could work with the City on a project we support while still fighting with the City on things we vehemently disagreed with. In neither instance were we only obstructionists nor were we capitulating and serving the mayor's needs. We were simply reflecting the direct input we got from the community we represented.

More than once the Coalition has been in litigation *against* the City for their policing practices while simultaneously working *with* the City, for example, in opening the Mission Neighborhood Resource Center or A Woman's Place. This cohesion can only be achieved when an organization is able to ignore personalities and power dynamics and look only at policy, program and funding priorities.

Accountable representation of any poor people's community ensures that sometimes, at certain periods a lot of times, you're going to lose the fight. And you have to take pride in the fact that you know ultimately you're not going to be defeated.

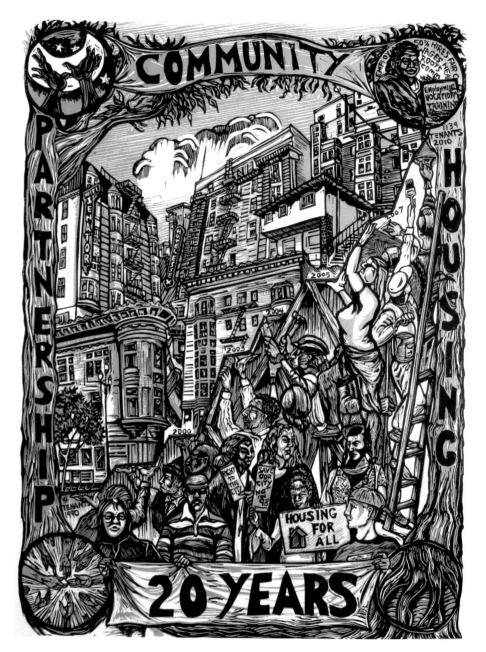

Figure 12
Art Hazelwood, *Community Housing Partnership 20 Years,* 2010, Linocut Print, 24 x 18", Courtesy of the Artist

In 1990, the COH together with the Council of Community Housing Organizations created the Community Housing Partnership (CHP), a community-based housing development corporation that creates permanent affordable housing and hires from within the community. The success of the CHP points to the strength of homeless people when they are viewed as collaborators and not merely as clients.

This print was commissioned to highlight the CHP's accomplishments on their 20th anniversary and as a tribute to long-time Executive Director Jeff Kosinsky as he was stepping down. Kosinsky is depicted near the middle as one of the many who worked together to lift the number of housing units that served formerly homeless people. Among the basic guidelines of the CHP are 50% hires from tenants, and voluntary rather than mandatory social services.

What is important to the people you're representing isn't: Did you win the fight? What is important is: Did you put up a fight? Did you take a stand? Are you willing to lick your wounds and keep fighting again tomorrow?

Artwork
Thanks in large part to a relationship between the Coalition's first *Street Sheet* editor and local artists, the Coalition learned relatively early about the power of artwork as a community organizing tool. When you look at any meaningful long-haul campaign that has been successful, be it the New Deal or the Civil Rights Movement, artwork gets people's attention and informs people about what is going on. It gets people to think. At the same time, it lifts the spirits of the groups who are involved and trying to bring about change.

It seems in issues of poverty, and most definitely in issues of homelessness, artwork has become mainly a fund-raising tool. For us, however, artwork is a cornerstone in building a movement, with images and messages created by community members who work together with the artists. Art serves as a tool to engage organizers and inform people about what the movement stands for. Artwork particularly plays a vital role when putting out a simultaneous message in multiple communities.

Funding
Raise money to fulfill your agenda. Don't create an agenda to raise money.

Being vigilant in how priorities are set and being clear what your priorities are is vital to the long-term integrity, and therefore existence, of any organization. Seek funding which supports your priorities, rather than setting your work plan according to funding which is available. You may never get rich, and you may lose a foundation or two along the way. But you can be confident that you will be able to sustain yourself and your priorities over the long haul through the support of individuals, community organizations and foundations that support social justice campaigns and trust in the ability of poor and homeless people to organize with integrity.

One of the most important lessons we learned at the Coalition was always to decide what's going to happen with funding long before the money arrives. Not just what is going to happen with this dollar or that dollar, but how we as a group are going to make decisions about how we relate to money and how we prioritize our spending.

Make sure someone in the group has the skills to report, document and track the funding that sustains the organization. If no one has those skills in-house, then you need to find someone with the same belief system who knows how to do this work and, at the same time, you need to begin to develop those skills internally.

To take advantage of the benefits of being a non-profit you must be accountable. You

can't receive funding as a 501C3 organization and ignore the requirements of your funders. Likewise you must follow IRS code reporting obligations to maintain your non-profit status. Understand your financials, be diligent to the requests of funders, be honest, have integrity and pay attention to the often-byzantine requirements. Above all, don't blow off reporting requirements.

Bottom line: all you need is somebody with integrity and brains who happens to love numbers. It's not rocket science. It's accountability.

Benefits of Long-term Existence

An important aspect of the Coalition on Homelessness is its long-term existence. Projects have ceased to exist and projects have evolved. COH has never become a personality-based organization. Hundreds of people have come and gone after serving in various capacities of leadership and responsibility. In many ways, everyone benefited from their skills and perspectives during the time these individuals were active.

As one of those people who moved through the Coalition to create the Western Regional Advocacy Project (WRAP), I know the benefits. The lessons we learned at the Coalition—accountable organizing, how to relate to money and the use of artwork—served us well implementing WRAP. We did not have to start at the beginning. And, the Coalition now benefits from seeing its process expanded to a regional campaign that is organizing with the same social justice agenda.

The Development of WRAP

By 2001 I had been speaking to other West Coast organizations—including LA Community Action Network (LA CAN) in Los Angeles, Sisters of the Road and *Street Roots* in Portland, *Real Change* in Seattle, *Street Spirit* and Building Opportunities for Self-Sufficiency (BOSS) in Berkeley/Oakland—about how we could best work together to fill the needs we all knew we had. Could we bring social justice homeless groups together to create one voice? Could we build power to influence the state and federal policies and priorities that were impacting our lives at the local level?

We agreed that we could and decided to set up a regional campaign called the Western Regional Advocacy Project. We worked together through emails and phone calls and developed the founding concept paper that established why we were creating WRAP and the spirit behind our coming together to create it.

Getting Started

The concept paper became our foundation. It established the standards of accountability for membership and the gap the organization was going to fill.

Figure 13
Christine Hanlon, *Vogue and Vagrant*, 1996, Oil on Panel, 25 x 43 1/4", Courtesy of the Artist

Christine Hanlon created a series of paintings of homeless people living on the streets. Her passion for social justice and her compassion for homeless people made her a natural ally for the COH and led to her becoming a regular contributor to *Street Sheet* as well as to *Street Spirit*.

This painting explores one of Hanlon's themes of the contrast between the dream of consumer society and the reality of poverty.

Once we were able to identify the common issues within our communities, we agreed continuous street outreach and community forums would be our standard of accountability and the basis of our work. All core members were committed to involving the community and to practicing non-violence. The gap we saw was that no one had created a platform where the voices of homeless and poor people themselves could be heard. These were the people who needed to be able to voice their priorities to have an impact on the policies and programs. We were in the process of determining how to address homelessness and poverty together.

Most importantly, we made a firm commitment that we weren't coming together to bitch and complain about what "they" are doing to us or how "they" weren't representing our community. We would decide on what *we* needed to do and focus our work on that.

Trust and Understanding
To fulfill our goals, we first had to establish trust and understanding among ourselves. In the beginning, as the organizer, I was the primary conduit. But more important

than members trusting me was when they began to trust each other. Separate groups working separately with one organizer do not create a movement. Separate groups joining together as one (WRAP) was vital to building the movement we needed to make the change we were striving for.

Again, another important organizing piece here is based on what we learned at the Coalition. The organizer's role isn't to say, "Here is my idea. This is what we're doing." It is to say, "Here is an idea. What do you think of it? Do you agree with it? Do you have a better idea and are you willing to put work into making it happen?"

Sure as hell, none of WRAP's founding member organizations needed somebody to come in to tell them what time it was. They needed an organizer to staff an accountable decision-making process so together they could create campaigns to respond to WRAP's priorities. As an organizer I staff the process. I don't lead the process. That is our model of how organizers in local communities also need to identify their role.

How we work together

We use regular work group conference calls to keep in contact with all the member organizations—implement our work plans, create our artwork and campaign materials, and design and implement our outreach. Just as important, we check in and support each other on local issues.

Perhaps the most important conference call is the monthly full-membership call. This is when all of WRAP's final decisions are made. Work groups make recommendations, but

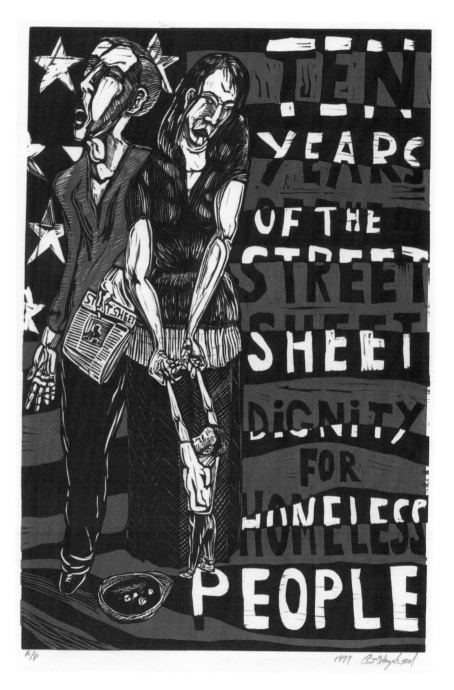

30

Figure 14
Art Hazelwood, *Ten Years of Street Sheet*, 1999, Linocut Print, 18 x 12", Courtesy of the Artist

After ten years as the editor of *Street Sheet*, Lydia Ely moved on. She had assembled a core group of artists including Jane "in Vain" Winkelman, Eliza Miller, Ed Gould, Casper Banjo, Christine Hanlon and Art Hazelwood. An exhibition of *Street Sheet* art was held at a Tenderloin community gallery to celebrate the visual voice that was such a crucial component of the paper.

This print was reprised in 2014 to honor *Street Sheet's* 25 years of continuous publishing as a reality based alternative to the mainstream media.

the full membership decides what the work groups will implement.

By far the best and most fun way of building our connections to each other has been with face-to-face full membership meetings. Because we have experienced organizers, WRAP has been fortunate to have tight agendas prepared through the work groups and decided on by the membership. At our face-to-face meetings, we have great facilitators who rotate throughout the meeting and we have active lively discussions that move us forward. Rarely will we entertain agenda items not already vetted through our decision-making process; thus we are not taken off track from our established goals.

As often as we can, our face-to-face meetings incorporate direct action with music and some dancing. These meetings are designed to be FUN. We always invite local groups to join us. Going out together, making a statement and having a blast are great ways to build camaraderie.

WRAP Street Outreach

Central to building our connectedness is conducting outreach *together*. Being able to identify where and how our issues overlap with the people in our local communities reinforces our belief that we need to come together, work together, and fight together to impact our communities together. No one issue, no one community is more important than any other. We win together or we lose apart.

Just as we did at the Coalition and as LACan has done in Los Angeles, in developing any campaign, any project or program, we begin by doing street outreach. If our priority was giving voice to homeless people, then we needed to hear what they had to say and what they were experiencing. We also agreed that every core member of WRAP would do street outreach in partnership with all other members. We would ask the same questions to ensure the priorities of WRAP matched the priorities of our local communities.

This is the process that drove our work. And we discovered that housing and civil rights were clearly the top two issues that applied on a local level throughout WRAP's membership.

Each One Teach One

Our primary reason for forming WRAP was to build strength by forming bonds with each other and our communities, and to capitalize on the fact when people and organizations come together, we all win. Each brings a level of expertise in individual areas. Some are really good at fund raising. Some are really artistic. Some run kick-ass community meetings while others might have their own newspaper or be awesome at street outreach or direct actions.

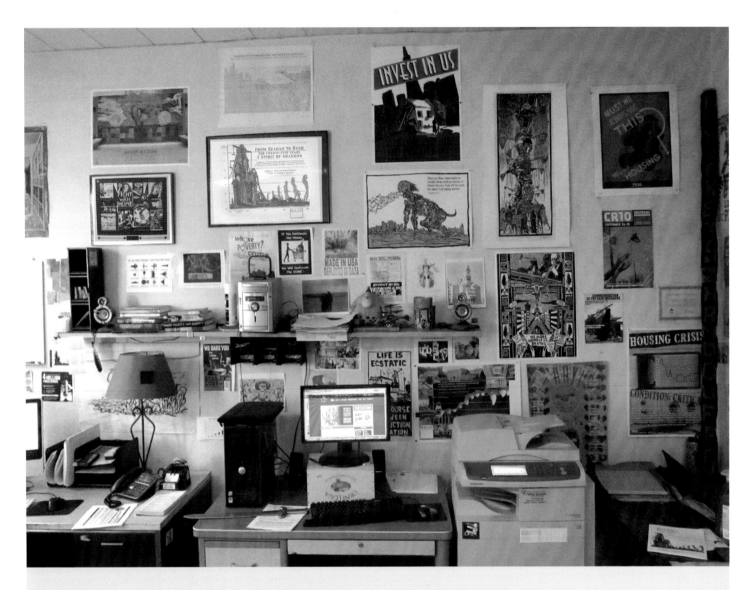

Figure 15
WRAP office, 2013, Courtesy of WRAP

WRAP's offices are covered with posters gathered from the struggles of many years.

HOMELESS PEOPLE ARE TODAY'S TARGET. THEY ARE NOT THE FIRST TARGET. AND, WITHOUT THE KIND OF ORGANIZING WRAP IS EMBARKING ON, THEY SURE AS HELL WON'T BE THE LAST TARGET.

What builds strength for us all is when we implement a learning process based on "each one teach one" and everybody learns from everyone else. Recognizing the strength of others and understanding your own weaknesses call for putting aside your ego and getting help where you need it or giving help where you can offer it. This means every organization involved in WRAP can learn from others.

Since our common issues came down to housing and civil rights, they make up the core of the work to which we are committed. In response, the very first thing we did was to create a voice for WRAP that spoke for all of us. We documented the correlation between the massive federal cuts for affordable housing in the late '70s and the advent of contemporary homelessness in the early '80s.

Without Housing

Our first big project was to research, write and publish *Without Housing: Decades of Federal Housing Cutbacks, Massive Homelessness and Policy Failures (2006),* a well-documented and irrefutable public education report. Together with dramatic charts and graphics, it creates one voice for all WRAP members. It answers the central question of why so many people were suddenly finding themselves without housing in the early 1980s. It connects the dots (see *When the Feds Abandoned Affordable Housing* page 90).

The crisis of homelessness was not inevitable. It had a human cause and *Without Housing* shows the cause and fills in the picture: federal cuts to affordable housing by over $50 billion a year between 1979 and 1983. That's when shelters began. That's when people were beginning to be forced to live on the street in numbers unheard of since the 1930s. That's where *Without Housing* begins.

We were nine organizations working together at that time, not just one of us individually writing a report. We deepened our ability to do research, our artwork, our graphic design, our printing and distribution process, and our organizing and public education follow-up. By working through our member groups, we could now get *Without Housing* into communities regionally and watch the ripple effect happen across the country. Individually we would have had a much more limited distribution.

We have never had exact numbers, but we do know that a minimum of 40,000 copies has been downloaded. We were able to publish an updated edition in 2010 and make available a version in Spanish the next year. As of 2011, everything is on our website, including Organizing Toolkit and Power Point presentations that are kept up-to-date and are free for anyone who wants to use them.

Without Housing was our statement: "WRAP Is Here!" It put our belief system and

our research out as a group for the first time. When we were asked, "Why WRAP?" we could say, "Look at *Without Housing*. That's why WRAP. That's why we're here."

Criminalization

We see criminalization of people who are without housing every day. More and more local laws criminalize sitting or loitering, sleeping on benches or in cars and giving food in public space. Our membership experiences it all the time.

We could have said, "Well, we all know this is happening," and left it at that. But we agreed that would not have been accountable organizing. So we did what organizers need to do. We adhered to our process with street outreach.

For each outreach, we created a standardized form to do multi-city outreach to homeless and poor people locally. We let them know this was part of building a movement on the West Coast and got information from them that would tell us how intense the oppression was and what laws were most commonly enforced. From that came a perspective, a set of priorities for doing in-depth research to identify exactly where these laws and campaigns and ordinances were coming from.

Once we clearly could identify that sleeping, standing and sitting were far and away the most egregious laws that were being enforced, we were able to make connections to historical trends in local government. We drew the connection between the trends now and the times when local ordinances were specifically used to drive certain people out of towns.

Using community forums combined with street outreach (what we call "accountable organizing"), WRAP members could show how today's quality of life or Nuisance Crime Abatement initiatives are the reincarnation of discriminatory laws of the past.

In the 1860s, we had the Unsightly Beggar Ordinances, often called the Ugly Laws. They forbade any one "diseased, maimed, mutilated or in any way deformed so as to be an unsightly or disgusting object" to be allowed in public places. There were thousands of Sundown Towns that warned African Americans and other despised ethnic groups like "Jewish, Chinese, Japanese, Native, and Mexican Americans" not to let the sun set on them. There were the anti-Okie laws that kept Dust Bowl refugees from entering California.

The correlation to what we see now jumped out at us. The laws we are seeing enforced around loitering or sleeping have a history. The experiences of the 1,300 people we polled seem less random in this light (see *Perception of Safety* page 94).

Homeless people are today's target. They are not the first target. And, without the kind of organizing WRAP is embarking on, they sure as hell won't be the last target.

Figure 16
Francisco Dominguez, *WRAP Protest*, 2011, Photograph, Courtesy of the Artist

In 2011, WRAP members came together in San Francisco for the Troubled Assets Relief Program (TARP) tour. TARP refers to the vast amounts of money thrown at banks in the wake of the 2008 financial collapse and the failure to address the needs of poor people or even the majority of people. The march physically linked up the range of struggles. Starting in Union Square to confront the privatization of public space, it then moved on to a hotel in support of striking workers, and ended at Senator Feinstein's office and a Wells Fargo Bank across the street to point out the relation between politicians and the banks.

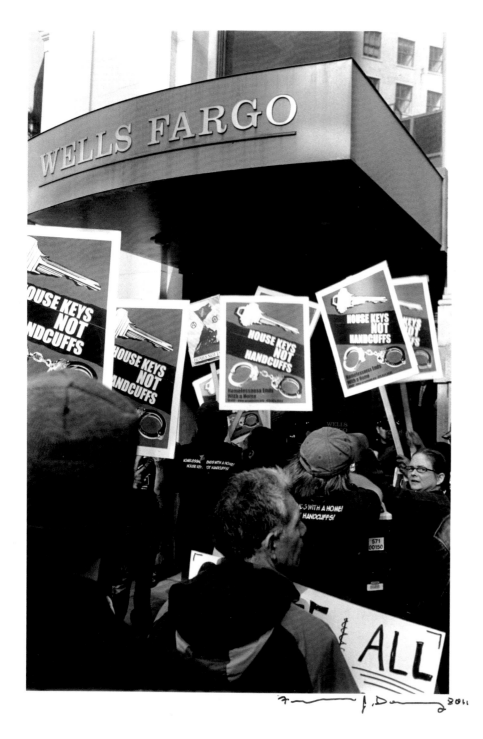

Thirty years into the re-emergence of homelessness in America, the powers that be, the media reporting on homelessness and the funding foundations overwhelmingly disrespect and de-value the realities of homeless people. They are dismissive of the impact of the crisis and what is means to the people who are living and breathing it every fucking day.

We were proud to have *Without Housing*, to have a carefully researched, factual overview that identifies causes and effects of this devastating crisis. But there was also the cold hard reality that WRAP didn't have the freaking power to change anything just yet.

So we did updates to our report. We created Power Point presentations. We wrote articles. We gave speeches. We went to any school at any level that asked us to come. All that is vital if we ever want to start a movement powerful enough to restore housing for all people.

At the same time, we still absolutely felt the responsibility to keep organizing, to keep responding to, and to keep fighting the massive displacement, dehumanization and criminalization that people were experiencing every day. Just like the housing reality, this criminalization reality was also universal in all WRAP communities and in many, many others.

Homeless Bill of Rights Campaign (HBR)

It's one thing to document people being criminalized for the mere fact

that they exist, for committing the crime of sleeping standing sitting eating surviving. These are activities all of us do every day, but only some of us are criminalized for performing them. It's righteous and legitimate to create fact sheets, posters, and newspaper advisories—whatever—saying how horrible this is.

It's a whole other thing to do something about it. That requires a much longer-term commitment and it's a hell of a lot more difficult. But in the long run, it's more meaningful to try to change it, to do something about it.

As we have shown, it's not new in American society that local governments are using laws and police departments in an attempt to make certain people disappear. But the fact that it's been going on in various incarnations doesn't mean we can't finally stop it from happening in the future.

Interpreted literally, many current local ordinances demand that people without housing keep moving—no sitting, no resting, no sleeping. WRAP's Homeless Bill of Rights would guarantee all people the right to move freely, to rest and sleep, eat and pray in public spaces without discrimination (see *This Crow Won't Fly* page 96).

Our HBR campaign does not set out simply to protect the homeless. Yes, it has as its core protection for homeless people, but it does this by making sure that no other segment of our society is going to be targeted by these local initiatives tomorrow.

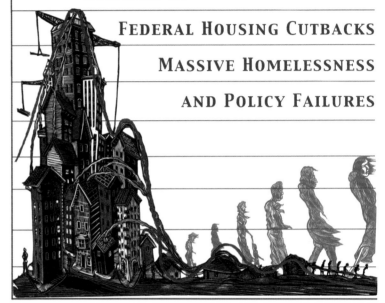

WITHOUT HOUSING:

DECADES OF

FEDERAL HOUSING CUTBACKS

MASSIVE HOMELESSNESS

AND POLICY FAILURES

WESTERN REGIONAL ADVOCACY PROJECT

Human Dignity: Making Connections to Other Social Justice Groups

A lot of this book has talked about the process of organizing—how issues have become identified and how communities have been involved in addressing and articulating the issues. But process in and of itself is not going to connect your organizing to a broader social justice campaign.

By ensuring human dignity is the context for our housing and civil rights work, groups and individuals who don't know WRAP or who may or may not be directly

The federal government played a major role in creating homelessness by cutting tens of billions of dollars from affordable housing programs beginning in the early 1980s. Since then, every federal plan to address homelessness has primarily focused on "fixing" homeless people rather than fixing the broken housing system. This approach has institutionalized a vicious cycle of homeless policy. As a result, millions of people live without housing in the US every year–including well over a million children.

In 2006, WRAP pushed back against these policies by a thoroughly researched report –*Without Housing*– which uses graphs, data and artwork to show the link between modern homelessness and the cutting of federal programs which address housing.

connected to homeless issues, can see themselves in our artwork, messages and beliefs.

The process we use to hold ourselves accountable and to identify our issues may or may not be the same or even similar as the process other groups use, and that's OK. No two groups are going to be identical.

What determines how we build a movement and strengthen all of us is how we speak to, and connect, our issues to the spirit of human rights. What does it mean to be a community? It means to understand that it's not bullshit when we say an injury to one is an injury to all.

In our homeless organizing work we must truly believe and truly identify with what we are saying. We need to speak out about how a lack of education for young kids living in poor neighborhoods or the systemic abuse that immigrant workers are exposed to every day connects to our abuse at the hands of local police departments. Otherwise we will be stuck in silo-based organizing efforts and forever frustrated when our issues don't seem to be connecting with the broader community.

Keeping the issue of homelessness floating in a lonesome bubble separate from poverty, racism, sexism or homophobia would be the worst. For years, we focused on the issue of homelessness, used "the homeless" in our vernacular and in doing that created an opening for monied interests to dictate the creation of a permanent underclass. Local politicians across the country have used homeless people as scapegoats, running for office on their backs, while being deeply funded by the financial industry. From San Francisco to New York, initiatives have been put on the ballot attacking destitute peoples and police programs have been created to displace indigents from central areas of commerce, all timed with the election of a particularly powerful local seat. This is only achieved when homeless people can be seen by the populace as some less human entity set apart from poor people in general.

Various protracted media campaigns have focused on changing voter perception of homeless people as those who have fallen through a tattered social safety net to a class of people who either chose to be homeless, did something wrong and became homeless, or who have something wrong with them. These deep-pocket campaigns have worked in part because collectively we have named people who have no choice but to live outdoors as "homeless." We have not done a good enough job connecting the U.S. housing crisis to broader issues of poverty and social injustices such as the criminalization of African American youth. People are poor because of social inequities; homeless people are just poor people who don't have housing.

WRAP's current efforts are focused on how we merge two realities: the lack of affordable housing that leads to house-lessness, and the houselessness that leads to

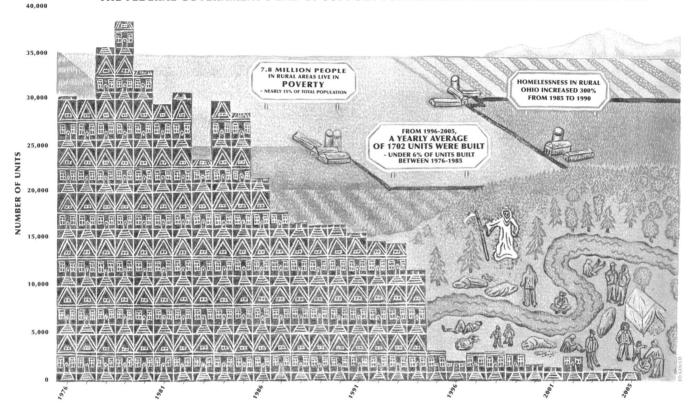

Figure 18

Ed Gould, *America's Forgotten Homeless People*, 2006, Digital Print from Original Woodcut Print, 18 x 24", Courtesy of WRAP

The use of artwork as part of the *Without Housing* report is an attempt to bring to life information that is void of passion and vitality, yet has such a dramatic and visceral impact on communities throughout the US.

The poster depicts the impact of cuts for rural affordable housing programs. Government programs established in the 1930s to address rural homelessness have been decimated since the early 1980s.

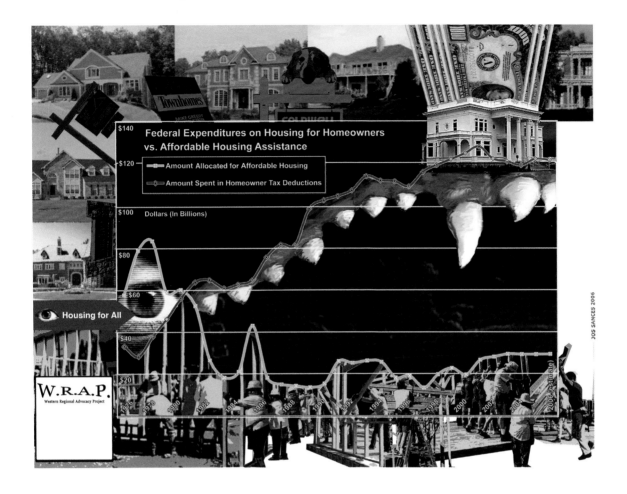

Figure 19
Jos Sances, *Housing for All*, 2006, Digital Print, 18 x 24", Courtesy of WRAP

The massive disparity between housing subsidies for homeowners compared to housing subsidies allocated for renters is presented as a dilemma resting on the jaws of a dog.

The graph lines cross in 1981, the year when there was more spending on mortgage deductions than on affordable housing.

criminalization. This is where we are launching a unified social justice organizing campaign under the banner of "House Keys Not Handcuffs."

Conclusion

We need a social justice movement in this country that creates laws at the state or federal level to ensure that local governments never again have the legal authority to criminalize the mere existence of human beings in local communities.

I've seen the way lobbyists and rich people walk through the corridors of D.C. or Sacramento or City Hall and they walk around as if they own the fucking place and, in fact, they do. But so do we. We need to own our government. We need to make sure that our government governs in ways that we can be proud of and in a way that respects all people's human rights.

We have to practice what we preach to really buy into this. Too often we see poverty and homeless organizations structured and run with the same classist and racist attitudes we claim to object to when our government does it.

After 30 years it's quite evident that addressing homelessness as though it is some sort of inevitable phenomenon, some new cultural aspect of our society, is being blind to reality. Homelessness is a visible manifestation of a society that is sorely lacking in justice.

To bring about change will take a movement in which we believe that how we treat each other is no different from how we allow our government to treat us. We need a system of governing that cuts through race and class and disability and treats us all as human beings. This is a righteous expectation for us to have of our government.

We need to connect immigrant rights, homeless rights, gay rights—our rights—with education, public housing, Section 8 housing. When we speak to all our communities in the spirit of what is socially just, we will be banding together to create a government that respects all of us regardless of color, immigration status, education level or housing status, and that truly sees every one of us as a human being.

HOMELESSNESS IS A VISIBLE MANIFESTATION OF A SOCIETY THAT IS SORELY LACKING IN JUSTICE.

Figure 20
Ronnie Goodman, *Homeless Bill of Rights*, 2013, Offset Print, 17 x 11", Courtesy of WRAP

The Homeless Bill of Rights campaign was launched with a call to artists to create work in support of rights at a state level that would push back against the criminalization and demonization of homeless people. Goodman created the logo and primary image for the campaign.

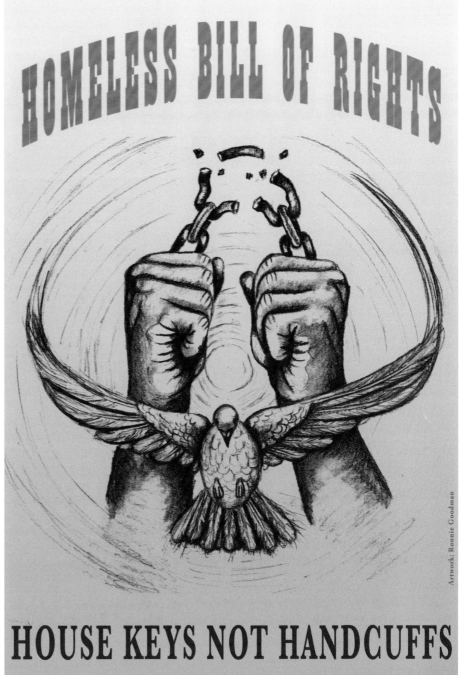

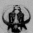

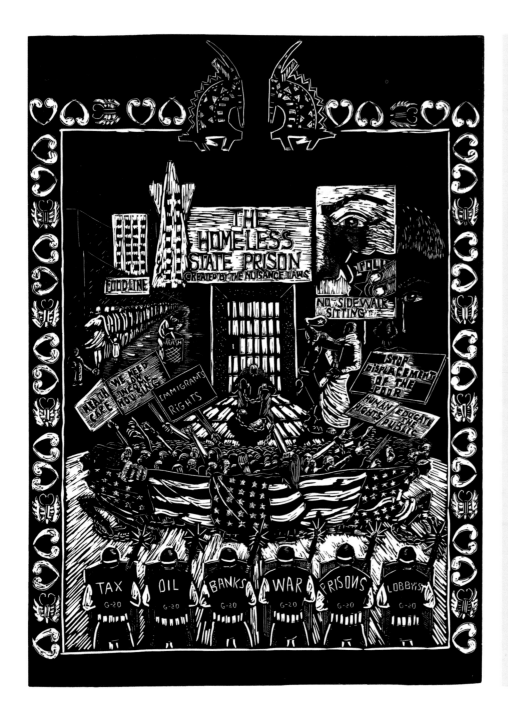

Figure 21
Ronnie Goodman, *Homeless State Prison*, 2011, Linocut Print, 30 x 22", Courtesy of the Artist

Ronnie Goodman created this print connecting the issues impacting poor communities while in San Quentin State Prison. His personal experience of homelessness and prison coupled with his artistic skill led to this powerful piece.

Shortly after creating this print Goodman was released into the exact system he represented—from prison to homelessness. He continues to create multiple works for WRAP, Hospitality House, and *Street Sheet*, making him one of the most prolific artists to create work on these issues in recent years.

Figure 22

Art Hazelwood, *Fighting For Our Right to Exist*, 2012, Screenprint, 22 3/4 x 16 3/4", Courtesy of WRAP

While the Occupy Movement was still active, WRAP organized a national day of action that included groups in 14 cities across the US and in Canada. April Fools day was chosen to mark the spirit which WRAP employs in protest actions—having fun in the struggle. The image portrays the cop of capitalism and his dog of hate whose belly holds a prison. Ranged against these beasts are a joyous band of lilliputians that may yet upset his plans of punishment and scapegoating.

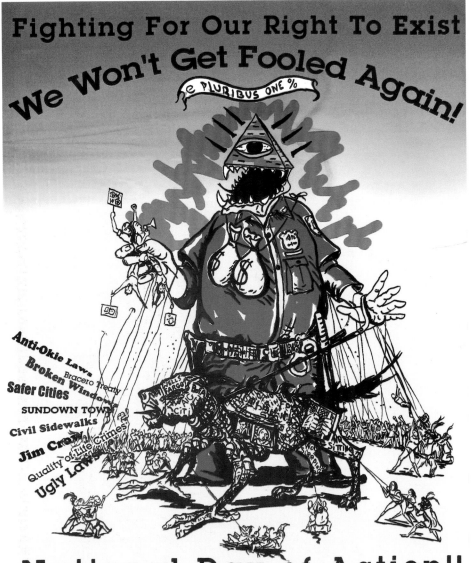

43

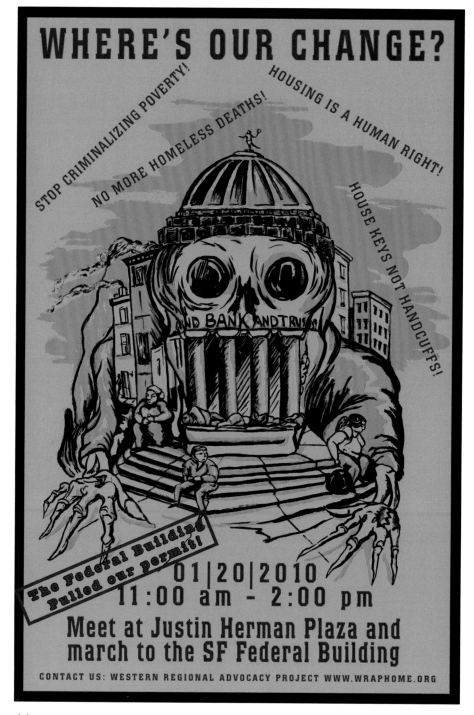

Figure 23

Art Hazelwood, *Where's Our Change?*, 2010, Offset Print, 17 x 11", Courtesy of WRAP

Obama's slogan in his presidential race was Change. This poster for a WRAP action in January 2010 asks Where's Our Change? The skeleton bank reaches out with grasping hands suggestive of its destructive power. While the banks reaped the benefits of the economic collapse, the people are left with nothing. A stamp on the poster indicates that the permit was revoked at the last minute by the Federal Building. Instead of gathering at the Federal Building, the march went down Market Street to the Federal Building in a pouring rain.

Figure 24
Poster based on artwork by **Ronnie Goodman** and **Francisco Dominguez,** *Join a West Coast Day of Action*, 2014, Offset Print, 17 x 11", Courtesy of WRAP

This poster was created for a simultaneous day of action conducted by WRAP members and allies in several cities in the Western US. WRAP has worked to make a consistent message that uses the same artwork for actions in multiple cities. By showing a unified front in all these communities as they work together for social justice, these unified actions highlight the breadth and the depth of the struggle. WRAP organizes activities together among its members and then hosts the events in separate cities.

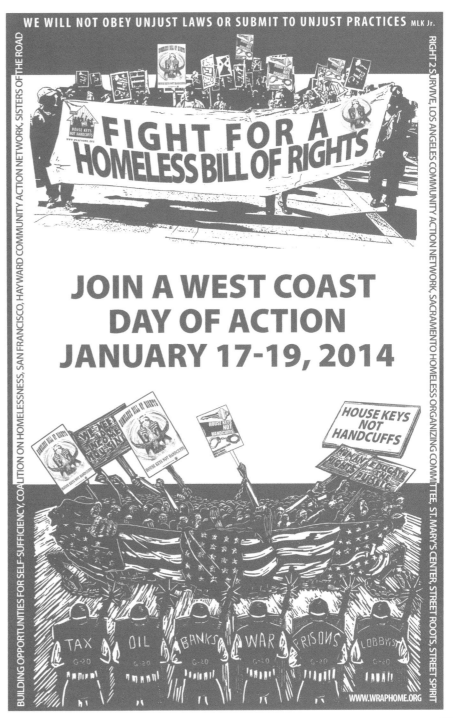

Figure 25 & 26

Artist unknown, *No More Homeless Deaths!*, 1999, Acrylic Paint on Canvas, 96 x 96", Courtesy of WRAP

The "No More Homeless Deaths" banner was used as a backdrop for speakers during a demonstration at UN Plaza in 2000. Pictured is Joyce Miller from COH Family Rights and Dignity Project.

The National Coalition for the Homeless and the National Health Care for the Homeless Council created a national event to memorialize those who died on the street, observed on December 21st—the longest night of the year—in cities across the country. This painting depicting ghostly images and grave markers was supplemented with spontaneous tributes written on the banner by friends and family of people who have died.

In honor of San Francisco's long running commitment to host these memorials, in 2000 the banner was sent by the National Coalition staff to the COH.

46

Figure 27
Malcolm McClay, *Homeless Deaths Poster Project,* in situ photo, 2001, courtesy Malcolm McClay

McClay worked with the COH in creating and distributing a series of 183 numbered silhouette paintings, one for every homeless person who died on the streets in San Francisco in the year 2000. On the night preceding the No More Homeless Deaths memorial, the posters were wheat-pasted all over the city. As much as possible, they were put up at the actual site where the homeless person had died.

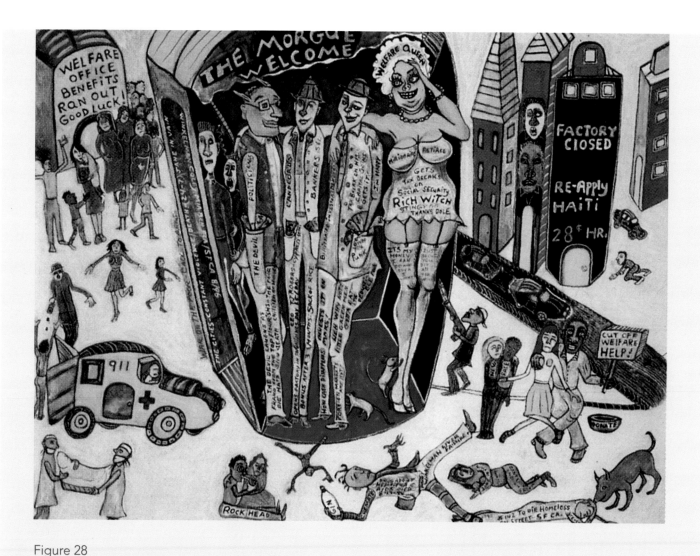

Figure 28

Jane "in Vain" Winkelman, *The Morgue*, 1990, Acrylic Paint on Paper, original size unknown, reproduced from *The View From Here, Celebrating 10 Years of the Street Sheet*, 1989-1999, published by Coalition on Homelessness

The whirling masses of the displaced, and the bizarre symbolism in Winkelman's work often seem to be more personal than political, but much of the text refers to attacks on the poor and disabled. In this painting, one of the three central male characters is labeled "Politician" and has his hand in a pocket stuffed with money that is labeled "The Devil." The other two figures are labeled banker and landlord. The message of a rigged system of inequality is clearly driven home by the wide range of people surrounding the elites.

WE WON'T BE MADE INVISIBLE:
Art of Homeless Activism

Art Hazelwood

Over the past 30 years, as the disastrous proportions of contemporary homelessness became the everyday world of American life, artwork has increasingly served as a vital part of organizing and bearing witness to the struggles of homeless people. In San Francisco, artists and activists have forged relationships that have continued to expand, with illustrations in the *Street Sheet*, wheat-pasted posters, protest banners, stencil paintings, murals, exhibitions, and official and unofficial public art campaigns.

The artwork in the pages of this book represents a small cross-section of the work created primarily in collaboration with the Coalition on Homelessness (COH) and the Western Regional Advocacy Project (WRAP). It represents many of the struggles that make up the history of these last 30 years.

From the early 1980s, when homeless people started organizing in the Tenderloin neighborhood, until they formed the COH, their actions were rarely represented by anything more artistic than hand-lettered signs. The formation of the Coalition, and especially the creation of *Street Sheet* in 1989, began the critical link between art and homeless issues. It has become stronger over the years.

Originally an in-house newsletter, *Street Sheet* quickly changed into a street paper sold by vendors who keep all proceeds from the sales. The first editor, Lydia Ely, brought in artists who gave visual form to the struggles of homelessness. Neither Ely nor anyone at the COH wanted to use photography because it often reinforced stereotypes or could show people who might not want their current condition to be publicized.

Ely turned to a friend from Washington D.C., Eliza Miller, who created iconic and expressive woodcuts that came to define the bold look of much of the artwork of the paper. Miller's "Fight the War at Home" became the early defining image of the COH and its broader fight to change the discussion from the "nuisance" of a person sleeping on the street to the social justice implications for a nation in denial (figure 2, page 10). Miller also covered the stories of the day, as in her 1990 print for the cover of *Street Sheet* that shows a San Francisco Police Department badge behind a flashlight in response to police sweeps of encampments (figure 10, page 22).

Soon after *Street Sheet* started, it attracted the second artist to give it a unique look—Jane "in Vain" Winkelman—who perfected her self-taught style while using the art

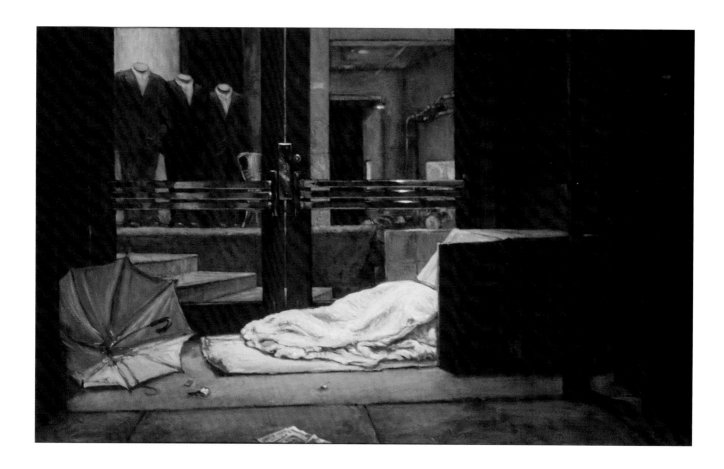

studio facilities of Hospitality House in the Tenderloin. The whirling masses of the displaced and the bizarre symbolism in her work may seem to be more personal than political, but her work of the 1990s often refers to attacks on welfare by the politicians of the day as well as ubiquitous greedy landlords. Winkelman's scream of injustice came from her own experiences of homelessness and struggle and speaks to those who have lived it. Her life experience was extremely relevant to the Coalition's mission of homeless people taking action and speaking for themselves(figure 28, page 48).

Early on, several cartoonists joined *Street Sheet*. Tom McCarthy, who had been working at the neighborhood paper *Tenderloin Times,* contributed a series of cartoons commenting on the destructive effects of city politics. Robert Curet, Joseph DeNeri and Tony Taliaferro joined him, among many others whose cartoons touched directly on the issues of the moment.

Figure 29
Christine Hanlon, *Wet Night On Sutter Street,* 1997, Oil on Canvas, 20 x 32 1/3", Courtesy of the Artist

Hanlon creates paintings that treat homelessness as a serious subject and portray the contrast between rich and poor with sophistication. The beauty of the image and the power of the composition create a kind of disconnect between the clashing ideas of what is beauty and who is it for. This image is implicitly critical of the power structure that offers ostentatious clothing while those outside sleep in the rain.

Ed Gould was a psychologist working with the Homeless Advocacy Project, which provides legal and support services to homeless people. His woodcuts for *Street Sheet* present scenes of their daily life: in waiting rooms, in parks, on the street. "World of the Homeless" 1999 (figure 40, page 64) is a sympathetic and humanizing portrayal of people's vulnerabilities as they scramble through the constrained world of their daily reality.

I came to the *Street Sheet* in 1994. After I had seen its bold graphic images, I sent in a woodcut I had made some years earlier. Soon I was creating artwork specifically for the paper, with an emphasis on imagery of economic injustice. Occasionally Lydia Ely would request art on specific themes. My print "Addiction" came out in an issue dedicated to the subject. The duality of addiction can be seen in the skeletal figure that is both forcing a drink and simultaneously appears as the addict's puppet (figure 30, page 52).

Christine Hanlon began a series of evocative oil paintings of homeless people on the streets of San Francisco in 1994 while she was a grad student at the Academy of Art. These paintings began appearing in *Street Sheet* in 1996. Her classical balance and tremendous technical skill represent the daily struggles of homeless people, whether against physical fatigue, the rain and cold, or against indifference and isolation.

There are many other *Street Sheet* contributors. Some are artists from Hospitality House who had regular contact with the COH. Others were brought in by the growing network of artists involved in the *Street Sheet*–Casper Banjo, Eric Drooker, Gato, Rigo, Roberta Loach and William Wolff among others.

In 1995, the Coalition and *Street Sheet* offered advice in the formation of an East Bay street paper, *Street Spirit.* Founded as a project of the American Friends Service Committee, it allied itself with various East Bay organizations to distribute the paper through vendors there. Founding Editor Terry Messman continues to nurture a long list of artists, photographers and writers who work with the paper. Some of the artists from the East Bay (such as Jos Sances and Doug Minkler) later also linked up with groups in San Francisco.

A 1997 project with the graphic design team Seeing Eyes Design involved a series of large scale posters on street kiosks as part of a San Francisco Arts Commission project on Market Street. The posters showed a series of board games that suggested the unpredictable nature and blind chance involved in homelessness. Each of the six posters was a collage of artwork by *Street Sheet* artists that reflected a separate

project of the COH: addiction, housing, civil rights, families, General Assistance and shelter outreach (figure 52, page 85).

Advertisement agencies funded two later public service campaigns involving bus shelter ads. Both had the look of advertising posters rather than art pieces, and their messages were more pointed. One portrayed how poverty was dealt with during the 1930s New Deal and contrasted it with how poverty is approached now. "Homeless People have been known to build more than cardboard boxes," for example, shows San Francisco buildings constructed under the federal government's New Deal WPA program that employed poor and out of work people (figure 49, page 79).

The second bus shelter campaign in 2004 used phrases overheard by *Street Sheet* vendors. Called "The Mirror," it reflected what much of society really thinks about homeless people despite the polite face people may put on it. This campaign generated a lot of outraged media coverage claiming "we would never say that." The imagery was typical of advertisements for beer or clothing, with happy people interacting, but with derogatory words attributed to them: "Quick, grab that quarter before that bum dives for it" (figure 48, page 76).

These campaigns mark a broadening of the use of artwork in political actions by homeless activists. Banners and posters

STREET SHEET

A PUBLICATION OF THE COALITION ON HOMELESSNESS
SAN FRANCISCO

APRIL 1997

BREAKING THE SILENCE
Drug Addicts Speak Out

As community members, advocates, and service providers, we have been silent about substance use too long. The quiet stems from the complexity of the issue — our culture's moralistic stance toward those who use, and the fear that opening a dialogue on substance use will only open us to further misunderstanding and attack. Our silence feeds the public health epidemic of substance use that tears apart individual lives, families and communities.

With this issue of the *Street Sheet* , we break the silence by taking on the issues of substance use and addiction from diverse perspectives.

SURPRISE!!
Drug Users Want Treatment

Who best to help us break the silence than users themselves?

During January and February of this year, volunteers (many of them currently or formerly homeless and not unfamiliar with the issue of substance use) went out into the community to talk to current users of drugs and alcohol. We made an effort to get the perspective of users who were also homeless or low-income. Our survey was not meant to be scientific; we used it to understand each individual's experience with the substance use treatment system in San Francisco and to gain insight on the ideal substance use treatment program from each user's perspective. In all, we talked to 482 people — in the street, at needle exchange sites, in shelters and drop-in centers, at detoxes, in jail, and, for some populations that are hard to reach (mainly women and kids), in treatment programs.

The specific results of the survey are provided elsewhere. Here we will explore what we have learned from talking to users and weaving together their individual experiences.

It is important to note that these responses are not statistically significant, they are just a reflection of what 482 users want and need. Many individuals were not able to respond to

the survey, because they were too intoxicated or their psychiatric disabilities too severe. These are the same people most often left out of the treatment system. Some populations are not represented here, such as addicted seniors, and others are underrepresented, such as people with mental illnesses.

Users Know What They Need

Starting this project, we hoped people would talk to us. We were struck by the candor we encountered from users. The silence surrounding them is profound — many said they had never been asked what they thought. We had hoped to talk to 200 people, but spoke to more than twice that number.

The process of talking to users in a concerted way has confirmed common sense — users know what they need and should have a real voice in the creation of policies and programs designed to serve them. 290 of the people we spoke to said that if they were to design their own program, clients would have input into the development and control over the operations.

Users Want Treatment

Besides the fact that users know what they need, perhaps the most important finding of our survey is that *users want treatment*. Of the active users, 90% said that if a program were

continued on page 4

© Art Hazelwood 1997

THE OSHUN PROJECT
For Families in Recovery

We sisters stand on the shoulders of giants like Sojourner Truth, Fannie Lou Hamer, and Maxine Waters. We are warriors who deserve the chance to achieve sobriety and joy. In that spirit and out of that love, the Oshun project is being created. As a group of African-American women and women in recovery, we are creating a program for families in the Tenderloin to find healing. Oshun — the name of the African deity who symbolizes love and healing — is going to be about life, power, and community.

African-American women and their children represent a significant part of the Tender-

continued on page 3

The April 1997 issue of *Street Sheet* was dedicated to the release of a study on addiction and treatment. Following the organizing philosophy of the COH, the study asked for input from those affected by these programs.

"Starting this project, we hoped people would talk to us. We were struck by the candor we encountered from users. The silence surrounding them is profound—many said they had never been asked what they thought. We had hoped to talk to 200 people, but spoke to more than twice that number.

The process of talking to users in a concerned way has confirmed common sense—users know what they need and should have a real voice in the creation of policies and programs designed to serve them. 290 of the people we spoke to said that if they were to design their own program, clients would have input into the development and control over the operations."

From the accompanying article *Surprise! Drug Users Want Treatment*

used in street actions, posters wheat-pasted on the street, these and other approaches amplified the message of activists in new ways. They also reflected a wider range of artists participating in activism on homeless issues.

Cartoonists and artists continue to create work for *Street Sheet,* but starting in the late 1990s artists in the Bay Area also became more directly involved in political actions through street posters and artwork for specific campaigns and actions.

An increasing awareness of the large number of homeless deaths led the National Coalition for the Homeless to create an annual event to memorialize those who died on the street, observed on December 21st—the longest night of the year—in cities across the country. The National Coalition for the Homeless painted a banner depicting ghostly images and grave markers. Friends and family of some of those who had died on the street supplemented it with tributes written on the banner. In 2000, the banner was sent to San Francisco where it was put to use as a backdrop at the annual City Hall memorial protests (figure 25 & 26, page 46).

The next year, artist Malcolm McClay teamed up with COH to create a series of 183 stenciled paintings; one for every homeless person who died on the streets in San Francisco that year. On the night preceding the No More Homeless Deaths memorial, the posters were wheat-pasted all over the city. As much as was possible, the posters were put up at the actual site where the homeless person had died (figure 27, page 47).

In the early 2000s, the first of the dot com bubbles swept through San Francisco, driving up housing prices and displacing poor residents. One byproduct of the fight against displacement was the creation of the San Francisco Print Collective (SFPC), a collective of artists who met at Mission Grafica print workshop. The SFPC worked with organizations by introducing activists to the tools of poster making: design, printing, and distribution so that they could create their own voice.

Beginning in 2001, after their initial campaign with anti-displacement organizations, the SFPC turned to work with the COH. "Fuck the Homeless, Save the Tourists," encapsulates the dominant view in the San Francisco power structure (figure 53, page 87). This large-scale poster showing Mayor Willie Brown on the cover of the *San Francisco Chronicle* was wheat-pasted in many locations, including in front of the *Chronicle* offices. Another poster from the SFPC announced the conference of the National Association of Street Newspapers (NASNA). Paul Boden remembers seeing Valencia Street plastered with NASNA posters and feeling the power of this very visible presence (figure 38, page 62**).**

In 2005, in order to push back against those forces attacking homeless people from the federal and state level, Paul Boden left the Coalition to form WRAP. Their first major project was the publication, *Without Housing: Decades of Federal Housing Cutbacks, Massive Homelessness, and Policy Failures* (figure 17, page 36). WRAP brought together a group of artists to illustrate the data, showing the real sources of national homelessness. *Without Housing* graphically shows the decrease in rural housing and declining spending on public housing in contrast to increased mortgage deductions and military spending. The artists who tackled the data had to create images that were evocative and yet still showed the factual basis of the argument that there was a cause behind the vast increase in poverty and homelessness over the last 30 years.

Not until this point were these issues addressed in so comprehensive a manner. The factual numerical background to the moral outrage was an important factor in the power of these images and their lasting effectiveness in organizing.

Ed Gould, Claude Moller, Jos Sances and I created posters for *Without Housing*. Jos Sances' image of the rise in the mortgage deduction tax breaks versus the decline of spending for affordable housing is presented as a dilemma resting on the fangs of a dog. Where the graph shows more spending on affordable housing, an eyeball and an arrow point to "hous-

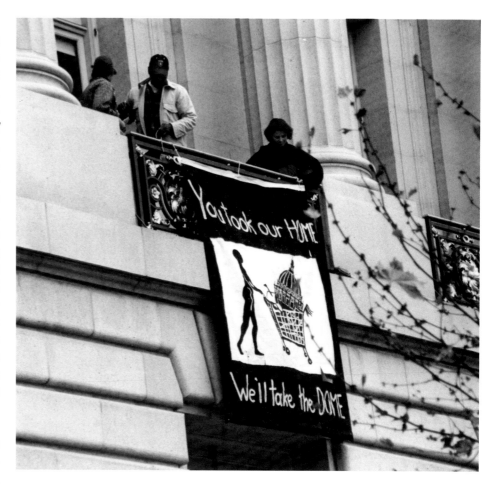

Figure 31
You Took our Home, We'll Take the Dome, photo of COH action, 2001, Courtesy of Coalition on Homelessness

A photograph of a clandestine banner drop off the balcony of the Mayor's office in protest of sweeps of homeless people. After protesters from the Coalition on Homelessness snuck into the Mayor's Office and made it out to the balcony, they hung the banner from the second story of City Hall.

This was never achieved again. To this day, whenever homeless activists enter the building in numbers higher than a dozen, sheriff deputies are immediately posted outside the Mayor's Office and doors are locked clear down the office hallway.

ing for all." The graph lines cross in 1981, the year when there was more spending on mortgage deductions than on affordable housing. The image seems to say, "Look here to see the cause of the current dog eat dog world, the gaping difference between rich and poor" (figure 19, page 39).

The Community Housing Partnership (CHP) offered an opportunity for more permanent artwork on homeless issues. The brainchild of the Coalition, it is run by and for formerly homeless people and manages and develops housing for formerly homeless people.

The Arnett Watson Apartments, built in 2008, were named to honor a Coalition activist. Because of the regard in which she was held, a memorial was conceived as a way to carry her spirit on to the tenants. One of Arnett Watson's many achievements was the creation of a system of appeal within the city's shelter system that allowed residents to protest their eviction. Jos Sances and I were selected to create this public art piece. We created a 13 x 20 foot ceramic tile mural, which portrayed Watson in the center. Two panels on either side of her represent the two sides of her life of activism, struggle and justice (figure 54, page 89).

Among the many battles waged by local politicians and police against homeless people are those originating out of right wing think tanks. They are promoted by the American Legislative Exchange Council (ALEC), which supports many "quality of life crime" bills aimed at further criminalizing homelessness. A 2010 example was a ballot initiative to criminalize sitting or lying on the sidewalk and several artists worked to draw attention to the basic injustice of this issue.

In the face of deep pocket spending in favor of the initiative, it was hard to break through the media silence. One form of protest that did succeed was a series of posters placed surreptitiously in bus shelters to replace advertisements. One poster drew parallels between the ballot initiative and laws used in the South that prohibited African Americans from sitting at lunch counters. It was titled "Sitting is Not a Crime" (figure 35, page 59). Although the measure passed in San Francisco, a second local attempt to criminalize sitting on the sidewalk failed in the City of Berkeley. Doug Minkler's poster (figure 37, page 61) was used in both campaigns and Jos Sances created another one for the campaign in Berkeley.

Having done the research and created the talking points for the argument against the 30-year long war on poor people, WRAP member groups came together in 2010 for a series of meetings and direct actions. And artists created the imagery for the actions.

The San Francisco Print Collective's "House Keys Not Handcuffs" protest placard can be read a long way off. The placard boldly makes clear the central theme that WRAP has adopted (figure 1, page 7). The placards became the visual strength of the protests. Jos Sances and Alliance Graphics in Berkeley made T-shirts and banners. The Great Tortilla Conspiracy printed slogans and artwork on tortillas and served the protesters edible political quesadillas. Filmmakers and photographers, including Francisco Dominguez, documented the actions with powerful images that showed the strength of the movement.

In addition to earlier means of dissemination, WRAP now uses the artwork in some new ways. The wraphome.org website is set up to share visual resources with street papers and organizations nationwide. Allied organizations can download and use the imagery. The artwork also works well to add visual power to email newsletters and public presentations.

WRAP also helped to organize the exhibition *Hobos to Street People: Artists' Responses to Homelessness from the New Deal to the Present*. The genesis of the show came through discussions between Paul Boden, New Deal scholars Gray Brechin, Charles Wollenberg and me. The traveling exhibition included art from past and present, contrasting the responses of both artists and the government. It paired artists who focused on the poverty of the Depression era—like Dorothea Lange, Richard V. Correll and Rockwell Kent—with contemporary artists. While a traveling art exhibition is not in the standard playbook of activist techniques, the show has had galvanizing effects in the communities where it was shown (figure 32 & 33, facing page).

In 2011, WRAP wanted artwork to address the revolving door of homelessness and prison. I had worked with Ronnie Goodman in the printmaking class of Katya Mc-Culloch at San Quentin State Prison. Goodman's artistic skill and personal knowledge of prison and homelessness led him to produce a linocut print representing the forces of the state in the form of "Tax, Oil, Banks, War, Prisons, Lobbyists" that are deployed against protesters; at its core it shows the prison system (figure 21, page 42). Shortly thereafter, Goodman was released into the exact system he represented—from prison to homelessness—but after his release he found the Hospitality House arts program and continued his artwork there. His work with WRAP, Hospitality House, and the *Street Sheet* has made him one of the most important artistic voices on homelessness.

Ronnie Goodman was also asked by WRAP to design the campaign logo for the Homeless Bill of Rights. It shows hands breaking free of chains and, significantly, a

In 2008, Art Hazelwood curated a traveling exhibition of artwork selected from the 1930s to the present that reflected the responses to poverty and homelessness by artists, the government and society at large. The show traveled to museums, art centers, universities and libraries throughout California as well as in Colorado. The dialog created at these exhibitions offered an alternative narrative to the existence of homelessness, where it came from and what can be (and in the 1930s what was) done about it. One point the exhibit emphasized is that homelessness is a social issue, and in the 1930s it was treated as a social issue by Federal Government policies that addressed systemic issues of poverty. In contrast, today, homelessness is treated as a failing by individuals.

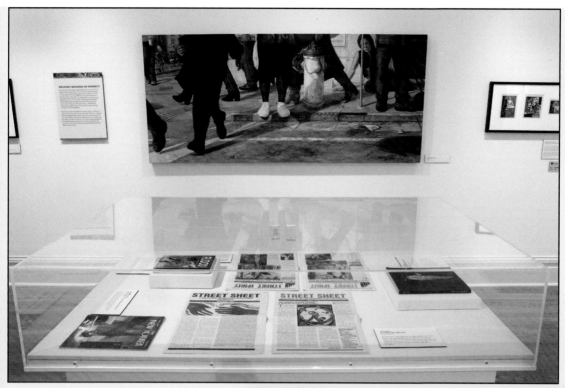

Figure 32
Hobos to Street People exhibition installation photo at California Historical Society in 2008, Photograph courtesy of Robert Berger

Figure 33
Hobos to Street People exhibition installation photo at Bakersfield Art Museum, 2008, courtesy of Art Hazelwood

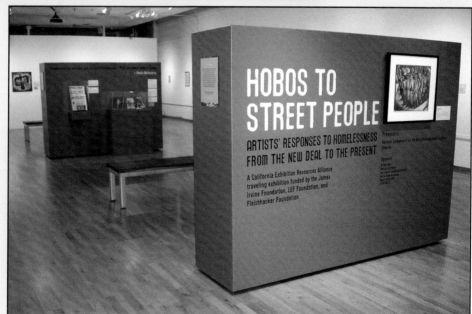

pigeon flying out—not a dove of peace, but a pigeon—as Goodman has specified. He felt the pigeon was more closely associated with homelessness than the dove (figure 20, page 41).

The Homeless Bill of Rights campaign also enlisted artists to create posters. Many were new to the struggle for homeless rights. These artists are not only fighting back against attacks on homeless people. They are creating imagery that shows what is possible. Instead of demonization and criminalization, society could focus on housing and rights.

As activists work to make social justice a reality, artists will continue to be there to lend a hand, reflect on the experiences of homelessness, document the struggle, and use their skills to give visual form to the real story of the ongoing war against homeless people.

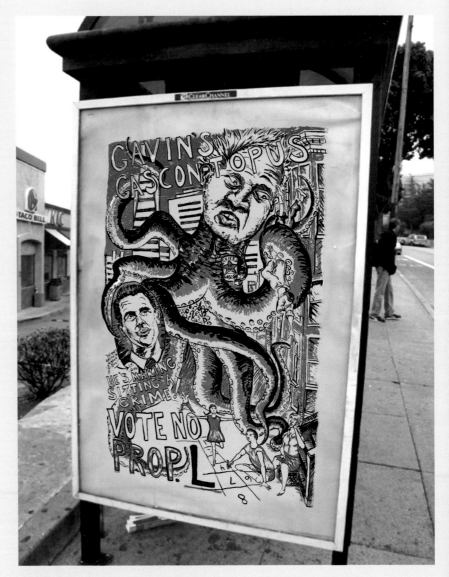

Figure 34
Sit/Lie Posse, on site photo, *Gavin's Gascon-topus*, 2010, Screenprint, Courtesy of Sit/ Lie Posse

Figure 35
Sit/Lie Posse, on site photo, *Sitting is NOT a Crime*, 2010, Screenprint, Courtesy of Sit/Lie Posse

In 2010, a ballot initiative in San Francisco that sought to criminalize sitting or lying on the sidewalk prompted several artists to create work that would draw attention to the basic injustice of this issue. In the face of deep-pocket spending in favor of the initiative, including advertisements during the World Series then taking place in San Francisco, it was hard for opposing views to be heard. One act of protest that did puncture the media wall of silence was a series of posters placed surreptitiously in bus shelters to replace advertisements. One poster drew parallels between the ballot initiative and laws used in the South that prohibited African Americans from sitting at lunch counters. Another made a cartoon image of chief of police George Gascón as an octopus attacking citizens for the crimes of sitting. Gascón and his political patron Gavin Newsom followed in the footsteps of previous San Francisco politicians in using the issue of homelessness as a way to enhance their political power.

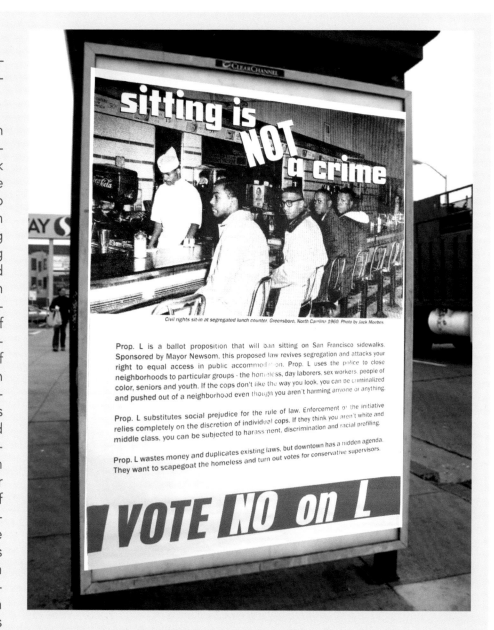

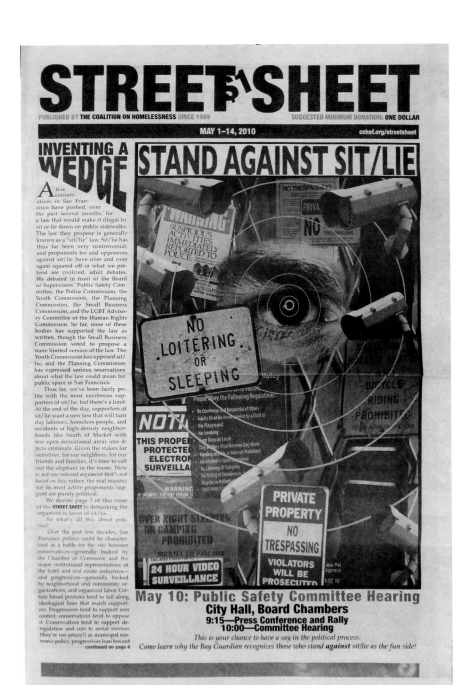

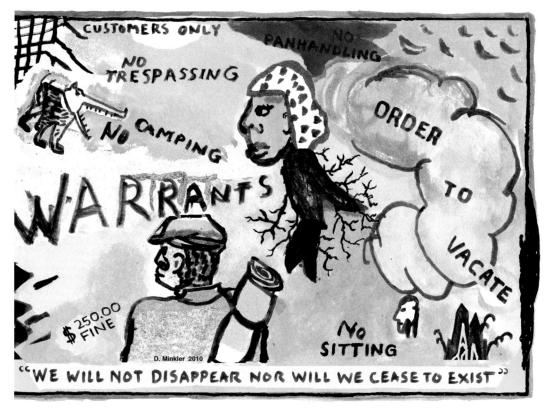

Stand Against Sit/Lie

For more information: www.cohsf.org www.standagainstsitlie.org

Figure 37
Doug Minkler, *We Will Not Disappear Nor Will We Cease to Exist*, 2010, Screenprint, 13 x 19", Courtesy of the Artist

Created for the San Francisco campaign against the Sit/Lie ballot proposal. It was used again in the campaign in Berkeley the following year where the fight to stop the ballot measure criminalizing daily activities was successful.

The similar language used in ballot initiatives to demonize poor people is due to their original source–conservative think tanks that create templates for conservative lawmakers to push in local and state arenas.

NASNA
NORTH AMERICAN STREET NEWSPAPER ASSOCIATION
2001 CONFERENCE

FEATURED SPEAKERS
BEN BAGDIKIAN
& BRUCE JACKSON

PERFORMANCES BY RAISING OUR VOICES
& PO POETS PROJECT
WOMEN'S BUILDING, 3543 18TH STREET
FRIDAY, JULY 27 8PM
FREE ADMISSION

NEW COLLEGE OF CALIFORNIA
777 VALENCIA STREET SAN FRANCISCO
THURSDAY JULY 26 – SUNDAY JULY 29 10 AM – 4 PM
FULL CONFERENCE $45 SINGLE DAY $20 (SCHOLARSHIPS AVAILABLE)

Figure 38
San Francisco Print Collective, *NASNA*, 2001, Screenprint, 16 1/2 x 22",
Courtesy of San Francisco Print Collective

In 2000, the San Francisco Print Collective (SFPC) was formed in order to
strengthen the visual street presence of social justice organizing locally.
In 2001 a series of posters was created working with the COH. This one
highlighted a national street newspapers conference.

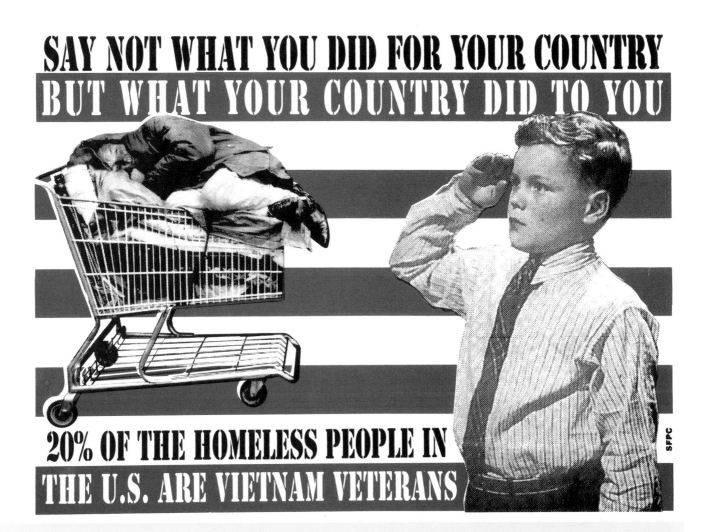

SAY NOT WHAT YOU DID FOR YOUR COUNTRY
BUT WHAT YOUR COUNTRY DID TO YOU
20% OF THE HOMELESS PEOPLE IN
THE U.S. ARE VIETNAM VETERANS

SFPC

Figure 39
San Francisco Print Collective, *Say Not What You Did For Your Country...*, 2001, Screenprint, 17 1/2 x 23", Courtesy of San Francisco Print Collective

A SFPC parody of the dangers of blind patriotism. The percentages of homeless people that are veterans is quite high but hard to quantify. According to the Pentagon, the rate of veterans who were becoming homeless after returning from the Iraq and Afghanistan wars was higher than from previous wars.

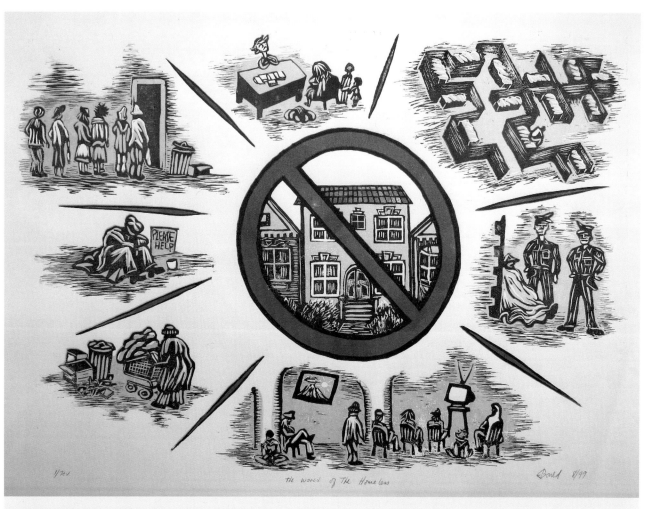

Figure 40
Ed Gould, *The World of the Homeless*, 1999, Woodcut Print, 12 1/2 x 18", Courtesy of the Artist

In a single print, the artist presents the myriad situations that reflect the impact on people when they lose their homes. In making artwork about homelessness, artists are often speaking to two separate audiences. One speaks to a general audience. The other acknowledges the invisible struggles of homeless people to themselves. This print speaks to both.

HOMELESS ORGANIZING AND CITY POLICY

Bob Prentice

After reading Paul Boden's reflections in *House Keys Not Handcuffs* about more than 30 years of homeless organizing in San Francisco, it made me wonder, what would it have been like if there had been no homeless organizing, no Coalition on Homelessness. Life in San Francisco, I suspect, would have been very different, not only for homeless people, but for all of us.

Shelter

For starters, San Francisco homeless programs would probably be based primarily on emergency shelter and short stays in SRO hotels. It was a group of homeless activists who broke away from Mayor Feinstein's Homeless Service Providers Coalition, where discussions were limited to emergency shelter and other temporary measures, to form the Coalition on Homelessness (Coalition) and advocate for more permanent solutions, including housing, employment, public assistance and healthcare. They were instrumental in getting then-President of the Board of Supervisors Nancy Walker to sponsor the Twelve Point Policy for San Francisco's Homeless, passed by the Board at the end of Mayor Feinstein's tenure, and the creation of *Beyond Shelter: A Homeless Plan for San Francisco* during Mayor Agnos' term. (see *Ass Out in SF* page 75) Working with allies in some service agencies and a few City staffers, they helped set in motion a more far-reaching approach to ending homelessness, or so it seemed at the time.

Without the Coalition, the shelter system would probably be very different. There would likely be no Shelter Monitoring Committee to track and report to the Mayor and Board of Supervisors on conditions in shelters, no Uniform Grievance Procedure to ensure due process rights for shelter residents and no legislation mandating minimum standards in shelters for health, hygiene and human rights. And, who knows, without the Coalition, we might even still have the Hotline Hotel program, which would continue to enrich central city slumlords and guarantee that hundreds of people would not have permanent housing each night.

Housing

If there were no Coalition, there would still be affordable housing development because the non-profit housing developers are strong, both individually and collectively, and they have been able to generate a political commitment to affordable housing in San Francisco. However, the Coalition on Homelessness was instrumental not only in reinforcing the importance of permanent housing as central to

ending homelessness, for which the non-profit housing developers have been the main source for both new construction and acquisition and rehab of buildings formerly owned by slumlords, but also in pressing for standards of affordability for people with very low incomes.

Without the Coalition, there definitely would be no Community Housing Partnership (CHP), which *House Keys Not Handcuffs* describes as perhaps its greatest accomplishment. Created jointly with the Council of Community Housing Organizations, the CHP today provides over 1,000 units of permanent affordable housing for formerly homeless people, while employing them in construction, maintenance and support services. In contrast to many federal grant-funded programs that treat homeless people as clients, the CHP was based on the premise that homeless people should participate in the development and operation of the places where they live.

Programs

Goodness knows, there are many programs that have been created to help homeless people. As *House Keys Not Handcuffs* makes clear, some have been good, while others strayed from their mission because they were not held accountable. Without the Coalition, though, A Woman's Place would not be available as a drop-in center, shelter and transitional housing program for mentally disabled women; there would be no Oshun, a 24-hour drop-in center that offers treatment for families with children living in the Tenderloin; there would be no Mission Neighborhood Resource Center, which serves mostly Latinos liv-

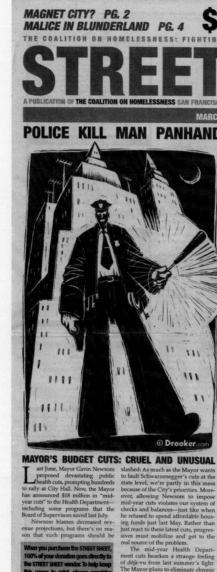

MAGNET CITY? PG. 2
MALICE IN BLUNDERLAND PG. 4
HOMELESS FAMILIES LETTER PG. 3
ORIGINAL POETRY PG. 6

$1

THE COALITION ON HOMELESSNESS: FIGHTING TO END HOMELESSNESS FOR TWENTY YEARS

STREET SHEET

A PUBLICATION OF **THE COALITION ON HOMELESSNESS** SAN FRANCISCO SINCE 1989 SUGGESTED MINIMUM DONATION: **ONE DOLLAR**

MARCH 2008

POLICE KILL MAN PANHANDLING, NO CRIMES CHARGED

It all happened so fast that I couldn't really react. I didn't move an inch. I was spread-eagle on my bed and looking down the barrel of a gun—12 guns, actually. I was in a situation where I was so shocked that my mind was frozen. I felt shock waves after that for a long time. In some ways I still do. If another police officer came up to me, I'd let them know that I see them as someone who violates human rights and breaks the law, not someone who supports them.

In October of 2005, 12 armed San Francisco police officers broke through the door of my small SRO (single-room occupancy) apartment and held me at gunpoint on my own bed. In this so-called "mistaken identity," the police could "mistake" my six-foot three-inch slender frame for that of a stout man just clearing five and a half feet. They could find my trimmed goatee a mirror image of a bushy grey beard. They could see my long, black trench coat as a short, brown sports coat.

On Sunday, January 27, San Francisco Police killed 55-year-old Leonard Michael Cole for panhandling. The *San Francisco Chronicle* reports, "...the death of the panhandler was as predictable as the sunrise."

"Get down on the ground! Hands in the air! I said get down!" 12 officers blasted through my door like bullet spray, and painted the white walls of my room a deep blue-black. They pointed their gun barrels directly at

me and cuffed my hands behind my back. I couldn't move. All the motion my body could produce was stolen by my heart as it tried to beat its way free from my chest, from the cuffs, from the guns, from this nightmare. I couldn't understand why this was happening.

According to local news reports, Heather Fong was driving through Russian Hill (an "upscale" area, like most others where people with money like to pretend they can get away from people without money), when she saw Mr. Cole panhandling near Van Ness and Greenwich. She put in a call to field operations and made sure that one of San Francisco's finest was available to "clean up" the problem, so folks going home to their overpriced condos wouldn't have to deal with the realities of the poverty their city and country have created. San Francisco is very sympathetic to people in condos. People without homes or those with inadequate shelter, though, are targets for the police, and are only allowed to be visible in certain areas under certain conditions.

You know, everyone that lives in the SROs knows that the police are always coming into our rooms and going through our things. I remember I was getting ready to go to Foods Co to activate my EBT card. I heard the door click open, and then they just barged in. They said it was because a black man in a coat committed a robbery three blocks away. Even though

continued on page 6

STANDARD OF CARE: LEGISLATING BASIC HUMAN RIGHTS

Imagine this: You are a woman and have been beaten and traumatized by the people who are closest to you, the people at your own home. You work up the courage to flee and seek out a shelter in the city so that you can rest, clear your head, and take your first step to beginning a new life. On the second day in this shelter, you ask for a towel so that you can take a much needed shower. The response from the shelter staff? "This is not the F-ing Hilton!"

This is not a fictional story: this is a testimonial from Ms. Rogers, one of countless people who are either homeless, have experienced homelessness in th epast, or advocate for better policies regarding homelessness, who stood up before the Board of Supervisors on Wednesday, February 20, to fight for legislation that will set up long-overdue Standards of Care within the city's shelters.

This legislation comes after a year long process wherein the Coalition on Homelessness worked with the Shelter Monitoring Committee, various City departments, shelter residents, and the shelter providers

themselves—most of whom noted that they were looking forward to having more clearly-defined standards that would make it easier to effectively operate their shelters and train their staff.

Before this process began, the Civil Grand Jury, a body of people that investigate various operations within the city and offer recommendations, had conducted their 2001-2002 investigation on "Homelessness in San Francisco." This report specifically recommended that the City: develop standards of care within the shelters; create a clients' "bill of rights;" develop system-wide, standardized operating procedures; and develop an integrated board including at least one homeless individual to oversee and hold accountable the (since then defunct) Mayor's Office on Homelessness, as well as the Local Homelessness Coordinating Board.

In November 2004, the Shelter Monitoring Committee—a product of legislation for which the Coalition on Homelessness successfully advocated—was finally established.

continued on page 4

MAYOR'S BUDGET CUTS: CRUEL AND UNUSUAL

Last June, Mayor Gavin Newsom proposed devastating public health cuts, prompting hundreds to rally at City Hall. Now, the Mayor has announced $18 million in "mid-year cuts" to the Health Department—including some programs that the Board of Supervisors saved last July.

Newsom blames decreased revenue projections, but there's no reason that such programs should be

slashed: As much as the Mayor wants to fault Schwarzenegger's cuts at the state level, we're partly in this mess because of the City's priorities. Moreover, allowing Newsom to impose mid-year cuts violates our system of checks and balances—just like when he refused to spend affordable housing funds just last May. Rather than just react to these latest cuts, progressives must mobilize and get to the real source of the problem.

The mid-year Health Department cuts hearken a strange feeling of déjà-vu from last summer's fight: The Mayor plans to eliminate chronic care nurses, shut down the city's only 24-hour drop-in center for homeless people, and decrease funding for the single-room occupancy hotel collaboratives.

continued on page 5

When you purchase the STREET SHEET, 100% of your donation goes directly to the STREET SHEET vendor. To help keep this paper in print, please consider making a one-time donation or becoming a STREET SHEET underwriter (pg. 8). We greatly appreciate the support of all of our donors and underwriters.

Figure 41
Street Sheet, March 2008, cover art: **Eric Drooker,** untitled, Scratchboard Drawing, Courtesy of Coalition on Homelessness

This image of a giant cop with oversize baton twirling and gun out and ready for use depicts accurately what all too many poor and homeless people see when those who are supposed to serve and protect us in fact demonize, harass and often shoot or beat us instead. Eric Drooker, whose artwork has been used often in *Street Sheet* over the years is an author of graphic novels and illustrated books; he regularly creates covers for *The New Yorker*.

ing in the Mission; and, probably others I don't know about. There was also the work the Coalition did to get the City to adopt policies supporting substance abuse treatment on demand and a single standard of care for mental health (see *Mental Health System: A Danger to Self and Others* page 82).

Even one of the programs that *House Keys Not Handcuffs* singles out as a failure—the MacMillan Drop-In Center—had some long-lasting benefits. Originally established as a refuge for intoxicated people to sleep it off in a safe and warm place to reduce the number of people who died on the streets, it was most strongly opposed by administrators of the substance abuse treatment system who thought it was enabling. Although the program drifted far off course from its original purpose, it initially established a commitment to basic humanity over treatment orthodoxy, and it helped create openings for future harm reduction programs.

Street Sheet

And, what if we had no *Street Sheet?* Many homeless people who might otherwise have been holding small cardboard signs with a clever handwritten phrase followed by "God Bless You," asking for money, earned collectively over $8 million as vendors instead, according to the Coalition's tally in 2011. The *Street Sheet* was also where art by and about homeless people reached its largest audience. Most importantly, however, the *Street Sheet* was the voice of homeless people and their advocates, writing about politics and life from their perspective. Without the *Street Sheet*, we would be left with the ranting of C.W. Nevius in the *San Francisco Chronicle* about how homeless people are bad for tourism.

Civil Rights

It's hard to imagine how much worse off we'd be if the Coalition had not been around to help fend off the attacks on homeless people's civil rights. Police have always hassled people who are down and out, but using law enforcement to be rid of homeless people became official City policy. In the battles over these policies, the Coalition had some successes, some partial successes and some defeats. The Coalition, for example, led campaigns that defeated a ballot initiative put forward by Mayor Jordan that would have prohibited sitting or lying on sidewalks except under certain circumstances, and got the Board of Supervisors to go on record opposing Mayor Jordan's notorious Nuisance and Quality of Life Criminal Enforcement, or Matrix Program, as well as an anti-panhandling ballot initiative. The Coalition was also able to help get the District Attorney to drop over 39,000 citations issued under the auspices of the Matrix Program. Later, during Mayor Newsom's term, however, both anti-panhandling and sit/lie measures were passed. The Coalition continued resistance to the anti-homeless measures and, working with the Lawyers' Committee for Civil Rights, was able to get many "quality of life" citations dismissed.

The attacks were not limited to law enforcement. On the premise that too many

homeless people were drawn to San Francisco because of its ostensible generous benefits, Mayor Jordan introduced an unsuccessful ballot measure that would have automatically deducted rent from a General Assistance recipient's check, leaving little for other expenses, including food. Subsequently, then-Supervisor Newsom introduced a successful "Care, Not Cash" ballot initiative that substantially reduced General Assistance cash payments in exchange for shelter or housing.

In both law enforcement and public assistance, the measures described view homeless people as a problem to be contained and managed. The Coalition has been the uncompromising moral force that persistently asserts the humanity of homeless people in contrast to the punitive approaches that have too often been part of City policies (see *The Three Year Itch* page 86).

WRAP

The creation of the Western Regional Advocacy Project (WRAP) was an important advance in coming to terms with one of the dilemmas of homeless organizing. Even though the roots of contemporary homelessness are national in their origin, the conflict has played out most dramatically at the local level. WRAP embodies the capacity to expand the scope of homeless advocacy while maintaining accountability to local activism through its structure as a collaboration among local coalitions throughout California and the West. The focus on national housing policy in *Without Housing: Decades of Federal Housing Cutbacks, Massive Homelessness and Policy Failures,* or their active sponsorship of a Homeless Bill of Rights in California, for example, translate the experience and activism from the local level to the larger issues that define local circumstances. WRAP reflects both the important legacy of local organizing in San Francisco through the Coalition and the potential to prefigure what is needed on a grander scale.

Homeless Organizing in Perspective

One of the limitations of homeless organizing is that homelessness is not an isolated phenomenon. While the accomplishments of the Coalition have been vital for so many people, homelessness is part of something much larger. Stepping back, it is important to note that during the period recalled in *House Keys Not Handcuffs*, the United States has experienced the greatest concentration of wealth and income, and greatest degree of inequality, since at least the 1920s. The United States is now the most unequal among developed countries. These developments, accompanied by the Great Recession and the foreclosure crisis, have justifiably provoked a great national dialogue about the fate of a beleaguered, vast "middle class." How is it possible, however, not to see how homelessness is the extreme result of these larger developments? As a society, we have retreated from any sense of a commitment to the principle that everyone should minimally have a place to live, a livable income, healthcare and security as we grow older. We will not get there by having tech billionaires donating to non-profit agencies or young hackers volunteering at homeless

Figure 42
Nili Yosha, *Homeless Go Home,* 2007, Digital Collage, 18 x 24", Courtesy of WRAP

This alteration of Norman Rockwell's famous painting of US Marshals escorting a young black student to a desegregated school was inspired by attempts in Congress in 2007 to expand the numbers of separate schools for homeless children. The bill did not pass. Though the immediate purpose for creating this poster was short-lived, the message continues to resonate.

shelters on Tuesdays. We need to revitalize a collective commitment to the common good, and as *House Keys Not Handcuffs* emphasizes throughout, embrace homeless people as part of our common humanity.

The next phase of homeless organizing hopefully will be part of something larger that can help bring about that vision of a better society. I hope there will never be a book about 50 years of homeless organizing in San Francisco.

Figure 43

artist unknown, *Must we always have this? Why not housing?*, Work Projects Administration, Federal Art Project, 1936, Screenprint, Courtesy of Library of Congress Prints and Photographs Division

This poster from the Federal Arts Project of the WPA has been used by WRAP to point out how levels of poverty and homelessness in the 1930s were addressed through government programs that were successful in reducing poverty.

We've been here before and we did something about it. Instead of blaming poor people for poverty, we created government programs.

The poster promoted planned housing as a solution to a host of urban problems. The Rorschach inkblot on which are drawn negative elements of city life suggests that one can see different things in these urban problems. The solution suggested for what should be seen in the inkblot is more housing.

Figure 44

Francisco Dominguez, *Must We Always Have This?*, 2010, Screenprint, Courtesy of the Artist

WRAP found posters from the 1930s to be potent in image and text. This poster by Francisco Dominguez uses his own photograph of one of several homeless encampments along the American River in Sacramento which expanded at the beginning of the economic collapse of 2008. These new Hoovervilles of the Lesser Depression point to further parallels to the 1930s.

Sacramento 2009

© Francisco Dominguez

Must we always have this?

Why not housing!

Join people from throughout the West Coast at Justin Herman Plaza in San Francisco We'll march to the Federal Building

January 20, 2010 11:00 am - 2:00 pm

more info contact WRAP www.wraphome.org

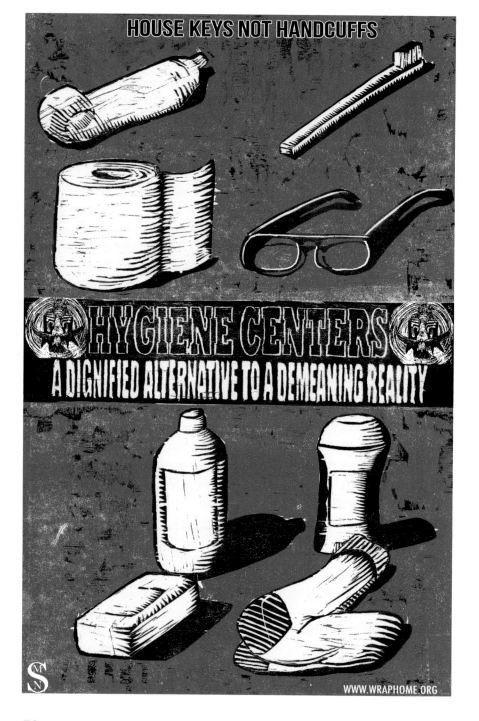

Figure 45
Maxx Newman, *Hygiene Centers*, 2013, Offset Print, 17 x 11", Courtesy of WRAP

As the numbers of homeless people continues to grow, access to hygiene and sanitation facilities both public and private have ironically continued to shrink. The Homeless Bill of Rights campaign calls for a right to sanitation for people without housing. Hygiene centers would address the basic necessities of life that people with housing take for granted.

Figure 46
Nili Yosha, *It Doesn't Take a Genius,* 2014, Offset Print, 17 x 11", Courtesy of WRAP

Families and children are far and away the fastest growing population of homeless people, yet because families are forced to hide from public view (or risk losing their kids), they are ignored and left to fend for themselves. 600,000 in 2006, 1.2 million kids in 2012–this poster points to the simple calculation that "Government Neglect = Homeless Families." Despite the terrible reality of the rising numbers of homeless children in schools their numbers are also a tribute to the strength of families keeping their kids' education going while living with no housing.

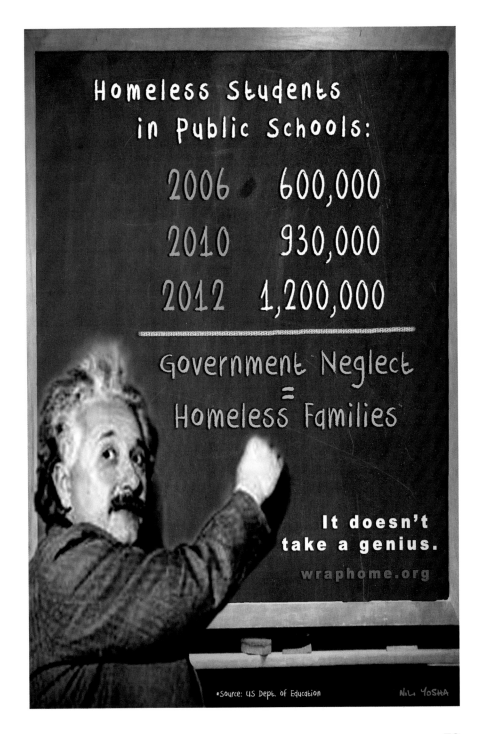

STREET SHEET

A PUBLICATION OF THE COALITION ON HOMELESSNESS
SAN FRANCISCO

$1 DONATION

JANUARY 1991

MULTI SERVICE CENTER

MULTI SERVICE CENTER

CURET

© Robert Curet 1991

ASS-OUT IN SF
An Historical Perspective on the Multi-Service Centers

In talking about the Multi-Service Centers, we need first to look back in history. In the winter of 1982-83, the San Francisco Board of Supervisors voted to place Muni buses — for homeless people to sleep in — in front of St. Anthony's in the Tenderloin and at the old General Assistance building at 1680 Mission. At the time, this was considered a humane alternative to sleeping outdoors in the rain. It was an answer to what was believed to be a *temporary* emergency situation.

1982: Response to "Emergency"

Within a few weeks, when the rains were still heavy and the homeless people had overflowed the buses, the City's first shelters opened up on floors and church pews. At the same time, Powell Street was undergoing extensive renovation, and the storefronts and hotels along that strip were basically empty. Thus the Hotline Hotel system was born.

It started out in two hotels facing each other, the Crown and the Stafford Plaza. Life was pretty wild at these places: six stories of SRO rooms with little or no supervision or screening requirements. Families, disabled people, substance abusers, non-abusers, semi-abusers lived together in two buildings.

1984: Shelters, Not Housing

The first attempt at labeling and housing/sheltering by "segment of the homeless population" began a year later, with the completion of construction on Powell Street and the move out of (now called a "transition" from) the hotels. We were all screened for eligibility for benefits. Families were moved to the Apollo and City Center hotels. Those deemed eligible for General Assistance were sent to the first presumptive eligibility hotels (which are still part of the system) and the rest of us were "referred" to what at the time were called "Emergency Back-up Shelters." We were supposed to be sheltered for only a maximum of a few weeks, since of course anyone who is homeless is entitled to aid that is supposed to enable them to get housing.

Even at this time — the middle of 1984 — shelters were not considered housing. They were seen, and should still be seen, as an emergency back-up to whatever was going to be put in place.

The Democratic National Convention came to San Francisco in June 1984. In the City's vigor to remove homeless people from in front of national TV crews, the Hotline Hotel program grew from five hotels to 28.

1986: "Programs", Not Shelters

Though the mid-1980s, sheltering homeless individuals became a profession. In order to achieve funding, shelters stopped being temporary-emergency-no frills-floorspaces with cots, and became treatment-rehabilitation-case management programs.

Near the end of her administration, former Mayor Feinstein tried pushing a plan to create three-tiered shelters — called "super shelters" — where people who have to pay for case management shelter beds. Supervisor and mayoral candidate Molinari was in favor of this plan, as were several shelter operators, which is why the Coalition and many others were so glad to see Art Agnos elected as Mayor.

1988: Beyond Shelter?

At our first meeting with Agnos a week after he took office, the Mayor asked about the community opposition to the super shelters, and the concept for the Multi Service Centers (MSCs) was born. The Coalition stayed involved through the contract and selection process for the development of these shelters.

But with the premature opening of the

Figure 47
Street Sheet, January 1991, cover art: **Robert Curet,** *Multi-Service Center,* 1991, Ink on Paper, artwork size unknown, Courtesy of Coalition on Homelessness

The article accompanying this cartoon tells the history of the development of the shelter system in San Francisco since 1982. That sorry history was acknowledged by Mayor Art Agnos. He worked with the COH after his 1988 election on what was hoped would be a successful shelter system. But as the cartoon depicts, the scale and the infrastructure were not what they had been hyped to be.

The Mayor tried to prevent any press from seeing the inside of the shelter, claiming the need for privacy; but as it became clear that there were problems, the Coalition was able to sneak in a camera and leak the footage to the press. The shelter was in fact still under construction.

***Street Sheet*, January 1991**

Ass-Out in SF: An Historical Perspective on the Multi-Service Centers

In talking about the Multi-Service Centers, we need first to look back in history. In the winter of 1982-83, the San Francisco Board of Supervisors voted to place Muni buses - for homeless people to sleep in - in front of St. Anthony's in the Tenderloin and at the old General Assistance building at 1680 Mission. At the time, this was considered a humane alternative to sleeping outdoors in the rain. It was an answer to what was believed to be a temporary emergency situation.

1982: Response to "Emergency"

Within a few weeks, when the rains were still heavy and the homeless people had overflowed the buses, the City's first shelters opened up on floors and church pews. At the same time, Powell Street was undergoing extensive renovation, and the storefronts and hotels along that strip were basically empty. Thus the Hotline Hotel system was born.

It started out in two hotels facing each other, the Crown and the Stafford Plaza. Life was pretty wild at these places: six stories of SRO rooms with little or no supervision or screening requirements.

Families, disabled people, substance abusers, non-abusers, semi-abusers lived together in two buildings.

1984: Shelters, Not Housing

The first attempt at labeling and housing/sheltering by "segment of the homeless population" began a year later, with the completion of construction on Powell Street and the move out of (now called a "transition" from) the hotels. We were all screened for eligibility for benefits. Families were moved to the Apollo and City Center hotels. Those deemed eligible for General Assistance were sent to the first presumptive eligibility hotels (which are still part of the system) and the rest of us were "referred" to what at the time were called "Emergency Back-up Shelters." We were supposed to be sheltered for only a maximum of a few weeks, since of course anyone who is homeless is entitled to aid that is supposed to enable them to get housing.

Even at this time–the middle of 1984– shelters were not considered housing. They were seen, and should still be seen, as an emergency back-up to whatever was going to be put in place.

The Democratic National Convention came to San Francisco in June 1984. In the City's vigor to remove homeless people from in front of national TV crews, the Hotline Hotel program grew from five hotels to 28.

1986: "Programs," Not Shelters

Through the mid-1980s, sheltering homeless individuals became a profession. In order to achieve funding, shelters stopped being temporary-emergency-no frills floor spaces with cots, and became treatment-rehabilitation-case management programs.

Near the end of her administration, former Mayor Feinstein tried pushing a plan to create three-tiered shelters–called "super shelters"–where people have to pay for case management shelter beds. Supervisor and mayoral candidate Molinari was in favor of this plan, as were several shelter operators, which is why the Coalition and many others were so glad to see Art Agnos elected as Mayor.

1988: Beyond Shelter?

At our first meeting with Agnos a week after he took office, the Mayor asked about the community opposition to the super shelters, and the concept for the Multi Service Centers (MSCs) was born. The Coalition stayed involved through the contract and selection process ·for the development of these shelters. But with the premature opening of the MSCs, the banning of free food distribution, and the stepped-up enforcement of Penal Code Section 647(i), the idea behind these centers seems to have gotten lost somehow.

The reason for this historical overview

is to try and illustrate the evolution of San Francisco's shelter system and explain that the MSCs, if and when they are completed and implemented as originally conceived, are simply an extension of the emergency shelter system. They provide the bare minimum of what a shelter should be. They are not an answer to homelessness. They will never· be a solution. They should be considered an option.

When the Coalition and other advocates have said this, Mayor Agnos has taken it as an insult. It's not meant to be. When Agnos tells the nation that he has solved homelessness in San Francisco by opening up shelters, homeless people take it as an insult. They should; it is one.

Multi-Service Centers-Super Shelters-Transitional Shelters-Drop-In Centers-Hotline hotels – none of these are solutions. They are options for people with nowhere else to go. Agnos is trying to hide a dramatic shortage of affordable housing by using his—our—police force to put people into the shelter system. And although he may not want to hear it from the Coalition, sooner or later he's going to realize that he has not and cannot resolve the issue of homelessness without permanent housing.

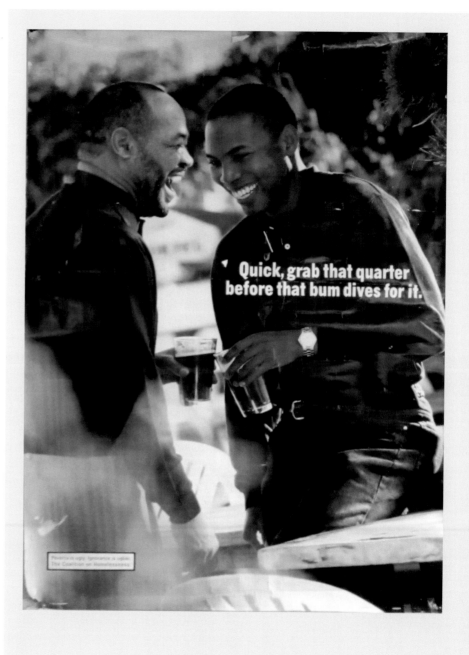

Figure 48
Paula, Jennifer and John from Odiorne Wilde Narraway and Partners, *Quick, Grab that Quarter...,* from "The Mirror" series, 1999, Commercially Printed Poster on Vinyl, 68 x 47 1/2", Courtesy of Coalition on Homelessness

A pseudo-advertising campaign called "The Mirror" was put together by an advertising agency working with the Coalition on Homelessness. The designers' friends posed for the photos which used text overheard by *Street Sheet* vendors. They reflect the ugliness of society's reaction to homelessness with the tag line, "Poverty Is Ugly. Ignorance Is Uglier." The campaign caused an uproar in the press which covered it on local television, in newspapers and on NPR.

Learning From the Past

Twelve years ago, I was one of "the homeless." We marched, side by side and sometimes hand in hand, with people from churches and community organizations, demanding access to treatment, an adequate income, and homes.

We might have been right, but we sure were stupid. Our message was very quickly compromised to a demand for food, clothing and shelter. Community organizations soon became agencies; more than one church spun off a corporation. The government was responding: City Hall formed a task force and suddenly meetings were taking place to formulate a plan. Instead of flyers to announce meetings, letters of invitation were sent to executive directors for 9:00 a.m. meetings, held at places no one had ever heard of.

Many still attended these meetings, took their friends, and spoke with great passion of the "growing crisis in our streets." Others perched like vultures waiting for the bucks to drop.

Government did what it does best. It chose the leaders, formulated a task force, set an agenda, allocated resources ($$$), controlled the media to frame public debate. Those invited to the meetings quickly became experts; it was only logical when the experts received the resources necessary to address this "crisis."

Agencies were never given the money to, nor could they ever hope to adequately address the key issues: access to treatment, adequate income, or homes. They took on the food/ clothing/ shelter issues, so popular with City Hall and the press. The shelters were all called Temporary Emergency Facilities; the clothing was secondhand; the food was industrial. But money had started to trickle in to community groups, systems were being put into place, and a program was being implemented. Government had done its job. The media were sympathetic to the cause, agencies were focused on their contract goals and billing processes, and the homeless were now "clients."

Very quickly everyone involved in this charade realized that without real solutions to this "crisis," the "'clients" would not magically disappear. There was a call to the federal government to do something to address access to treatment, an adequate income and housing, or this crisis would destroy America's "once-great" cities.

The federal government responded. It formed an Interagency Council and flew in experts from all over the country. It formulated a plan. Soon 11,000 emergency shelters were open, and Mitch Snyder became a national hero. The Stewart B. McKinney Act was passed, and transitional housing was born. The Fed, with all its resources and experts, knew it couldn't get away with just food/ clothing/ shelter. (The locals had tried

that, and it wasn't working.) They also decided that access to treatment, an adequate income and housing were market commodities protected by the corporate desire to maintain the status quo.

The answer to the Fed's dilemma was transitional housing. It is neither treatment nor housing. A case manager and temporary hotel room are a poor substitute for treatment and a home – but "the homeless" should be grateful, we say, since it's better than the streets.

The experts have done a good job in their analysis of the homeless problem, and the trickle of funds is now a small stream. Thousands of people are "displaced" because their buildings are sold and developed as transitional housing programs. Community organizations that became agencies are now forming subsidiaries. Case managers are told to rehabilitate their clients.

Meanwhile, government can point to the millions it has spent to prove that it is adequately addressing "the problem." If any problems still exist, they're because people choose to be homeless. They're bad clients, living under the guise of homelessness, so they can panhandle. We are running shelters, soup kitchens, and clothing distribution centers. We have case managers in shelters, transitional housing programs, drop in centers and outreach workers, support service staff and Multi-Service Centers. We're doing everything we can.

Quite an elaborate system has been created to avoid addressing the actual causes of homelessness. Amazingly enough, nowhere in this bureaucratic maze of governmental denial does a homeless person receive access to treatment, an adequate income, or a home.

Market forces have prevailed, an industry has been born, and, once again, poor people alone are to be blamed for poverty.

Street Sheet, December 1994

Break the Blockout

The holiday season is here and once again poverty is an issue of charity and compassion. Agencies are in dire need of donations, and poor people are our neighbors in crisis. We know this is true, because we heard it on the news. Every day, in every medium, we learn about the plight of people in OUR community who are cold, hungry, and in need.

Not like those poor people we've been learning all about during the previous 10-1/2 months this year; these are the mid-November to January 1 poor, the good poor, the ones who relieve the corporate guilt of the major news outlets and their sponsors.

Gone are the *Examiner*'s derelicts and denizens. So too KRON's frauds and junkies. Say goodbye to the *Chronicle*'s urban campers as they go on sabbatical during this "Season of Sharing."

Consider this an early Christmas present from the great Christians on the editorial boards. Six weeks with no bums–a hell of a lot more than the Matrix program with all its money and police has been able to do.

And it's not just here. In every city and town across this country, the derelicts and welfare cheats have disappeared, all at approximately the same time (the week of November 15). All return on exactly the same day, January 2. Presi-

Figure 49
Designer/Artist Unknown, *Homeless People Have Been Known to Build...,* 2002, Commercially Printed Poster on Vinyl, 68 x 47 1/2", Courtesy of Coalition on Homelessness

This bus shelter poster, created for the COH by an ad agency, points out that when provided with the resources and opportunity homeless people contributed to the construction of much of our most valued infrastructure. The Federal government provided that assistance in the 1930s through the WPA. Today, rather than paying people for uplifting work, poor people are made to work for below minimum wage to receive General Assistance.

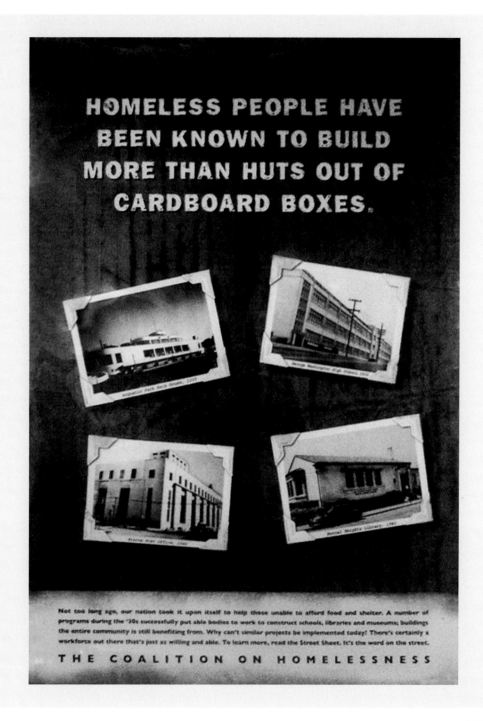

dent Clinton should take note; no doubt that anybody who could achieve this feat year round would be named President for Life.

And we know it's true because we learned it on the news.

Sarcasm aside, when, you might be wondering, does the news media present poverty accurately? Surely poor people are not as morally corrupt as they are frequently portrayed to be from January until mid-November – nor are they as pathetically victimized as they are portrayed from mid-November until January. You ask yourself, "So when do we get the truth?" You don't. And the reason you don't is because poverty has very little to do with people.

Poverty affects people. Some of us live in it. Some of us live uncomfortably close to it. Almost all of us can name someone we've met who comes from it, and a couple of us (a very powerful couple) see it when we look out the Mayor's office window into Civic Center Plaza. But the absolute, documentable, mostly untold reality of the elements that must exist in order to create poverty, and also to end it, have very little to do with any individual (good or bad) story of a poor person.

A poor person has never moved a factory to Korea. A poor person didn't come up with the idea of Food Stamps. And no poor person would have been stupid enough to believe that the Matrix program could alleviate homelessness. Very

few poor people have bootstraps, and nobody achieves success without at least a small amount of help from someone.

Poverty is about politics, money, and government priorities—issues that the news media does not talk with poor people about, but about which poor people have very strong and—surprise, surprise—divergent opinions.

The Coalition on Homelessness is committed to serve as a regional representative for those in our community who use any communication medium and want to see well-informed and accurately articulated public interaction on the issue of poverty in this nation.

Because, while I hate to bust your holiday bubble, the bad poor people really haven't left us, and the good poor people didn't suddenly appear. The only thing that has changed is the tone of the language used to describe us.

Street Sheet, November 1997

At Our Core

A little over ten years ago, a bunch of burned-out and angry social service agency staff were having an all too common after work drinking session at Harrington's on Jones Street. Many of us had been homeless and were working at various shelters or doing organizing. Others were people who had landed in this bar from the more traditional social work background.

But we all had one belief in common.

When poor people or their organizers speak out without their agency's support, they are too often written off as uninformed advocates and their words discarded as hot air.

If agencies try to speak out without their community's support, they are too often silenced with indirect—and sometimes very direct- threats to their funding.

While both group had their own group meetings, the provider's agenda was controlled by the city through the department reps who staffed the meetings. The Homeless Task Force, a group of formerly and currently homeless people, kept folding and recreating itself every couple of years.

As both community people and service providers, we felt ourselves being played off against each other by the city.

One night, we finally wrote down- and I swear this is true- on a napkin a possible

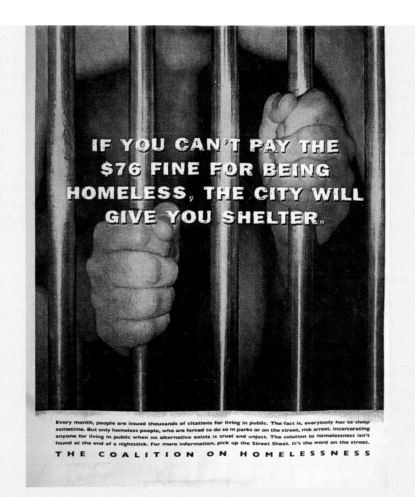

Every month, people are issued thousands of citations for living in public. The fact is, everybody has to sleep sometime. But only homeless people, who are forced to do so in parks or on the street, risk arrest. Incarcerating anyone for living in public when no alternative exists is cruel and unjust. The solution to homelessness isn't found at the end of a nightstick. For more information, pick up the Street Sheet. It's the word on the street.

THE COALITION ON HOMELESSNESS

Figure 50
Designer/Artist Unknown, *If You Can't Pay...*, As reproduced in *Street Sheet*, 2002, Courtesy of Coalition on Homelessness

The staff of a local ad agency worked with the COH to create a series of bus shelter ads to encourage the public to buy and read *Street Sheet*. Each ad ended with the tag line, "For more information pick up the *Street Sheet*. It's the word on the street."

This poster depicts the effects of the seemingly benign tickets issued to homeless people. The tickets do in fact lead to people being put in jail for the crimes of sitting, sleeping, standing still or lying down. Today there are new laws, so new fines, but the average is $105.

structure for a non-government-funded group that would focus on maintaining a forum where everyone could come together and speak safely on issues of social and economic justice.

It was during the process of outreach in passing this idea around and getting hundreds of people's input on the idea that the Coalition was truly formed.

There were two primary motivations for most of us who helped form the Coalition on Homelessness.

First, we wanted to insure that there was the input of homeless people in all decisions that were made by others that impacted on their lives.

And, just as important, we wanted to protect agencies from threats to their funding for speaking out on issues of social policy.

Doing extensive outreach to get people's insights and opinions has always been a mainstay of how we function. Workgroup meetings are vital to set strategy and a framework for your outreach, but it is only through exposing your ideas or plans to large numbers of concerned individuals that you can check out its validity and gauge the level of community support.

You would be amazed how rarely homeless people or front-line staff are asked for their input when a new policy is under consideration or a new program is being designed, even when those policies or programs will directly impact their work or their lives.

When they are asked, they have a definite voice. Check out whenever you see a homeless person or a poor person interviewed on TV when they are asked about their personal story or their perspective on an issue, and you will see what I mean.

The Coalition does an extensive amount of outreach throughout the affected community for input and recruitment. They pick up new ideas which leads to new agenda items which drives the agenda for the next workgroup meeting. This solidifies the common ground. So today, like our beginning, a bunch of people with similar concerns and frustrations get together. They draft recommended structure to address a problem. Then they go to work on it.

This process is the Coalition. Every Coalition project has a workgroup, has an outreach component, has dedicated staff - paid and/or volunteer - and has an implementation plan built on community support.

And because of the process by which that plan is created, Coalition staff and members also have a fearlessness in pushing these plans forward to creation through the politics of government and media perception.

So, as you read the articles in this issue that talk about our project creation, advocacy efforts, and organizing strategies, relate it to this core structure. See how these efforts are built upon this core foundation to include their areas of primary focus.

You never know how strong a passed around bar napkin can be.

Street Sheet, May 1998

The Mental Health System: A Danger to Self and Others

This special issue of the *Street Sheet* is dedicated to mental health, a key health issue too little discussed, and often ignored or misunderstood.

Psychiatric illnesses are diseases of the brain and should thus be treated like any other medical condition. Our strategy for ensuring access to mental health treatment as a basic health care right includes two vital components: education to debunk the misinformation and stigma surrounding mental illness; and advocacy to ensure equal access to mental health treatment on demand in the least restrictive setting available.

For the last several years, the mental health system has been slanted away from prevention and geared toward only serving those in crisis. Now the system is changing to allow for broader access to much needed services. However, it is a classic set up: while more people will be eligible for services, funding for services will actually be reduced, resulting in fewer services for everybody.

Mental illnesses are diseases. Serious mental illnesses, such as schizophrenia, are now recognized as having actual physical origins in the brain and are not, as previously thought, caused by demon possession, poor toilet training, or

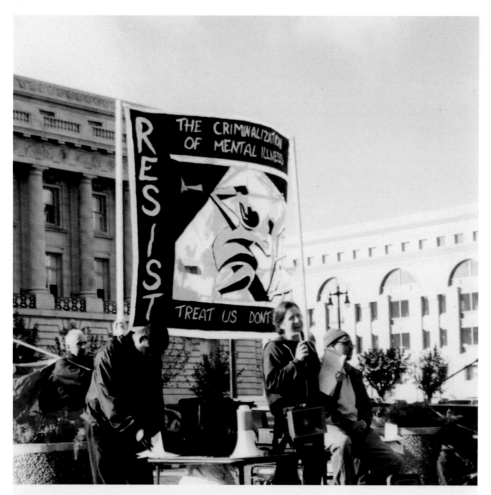

Figure 51
Protest at San Francisco Civic Center against the criminalization of mental illness, 2002, banner by **Allison Lum,** Courtesy of Coalition on Homelessness.

In 2002, the COH held a protest against the implementation of forced outpatient treatment in San Francisco. After a state law required counties to approve its implementation before it came into effect, the COH struggled successfully over the course of several administrations to oppose the implementation. In 2014, a watered down version of the law passed. The speaker is Jennifer Friedenbach, currently director of the COH.

moral weakness. However, people who have experienced sufficient trauma at an early age also show a difference in the chemical make up of their brain, indicating that serious mental illness is both an inherited disorder and/or a response to external events. What is clear is that mental illnesses are brain disorders and as such should be treated as other serious medical conditions.

Despite this information, people with psychiatric disorders face profound misunderstanding and discrimination, generated not only by society at large but frequently by the medical profession, which in theory is designed to treat these disorders. Even with medical advances and knowledge, people with mental health problems are routinely told, "Get over it" or "It is all in your mind," and are forced to hide their disorders. Because of the stigma, these major medical conditions go untreated at the expense of a person's quality of life at best, or their very life at worst. Since mental illness is fundamentally a brain disorder, treatment and all health care should be provided as a basic right. Currently mental health services are hoarded and rationed for the few, and access and treatment are not provided on par with other health conditions. It has not always been this way.

A Brief History

In 1966, California's then Governor, Ronald Reagan, began a process that set a pattern for the rest of country: deinstitutionalization. While he garnered

83

popular support for this notion by insisting community care would be available, Governor Reagan in no way did this for humanitarian reasons; rather he simply wanted to save the State millions of dollars spent each year to confine people to the IMD (Institute for the Mentally Diseased).

In 1998, deinstitutionalization is often regarded as the cause of the large numbers of disabled homeless people living on the· streets, in shelters, and in the jails of every city in this nation. Many people—out of fear, frustration, compassion or misunderstanding—think that reviving these massive (5,000 patients in a facility) locked institutions will solve issues such as homelessness, crime, or drug abuse. What is missing from the media debate around institutionalization is the history of successful de-institutionalization and why the system of community-based care is failing today.

In the late 60s and early 70s, San Francisco's response as a community to de-institutionalization was innovative and effective. People leaving locked facilities and returning to their lives were able to live in halfway houses for up to 24 months while attending outpatient treatment, going to school, applying for SSI, or getting vocational training. They were encouraged to live communally with a small number of peers, sharing household responsibilities and providing emotional support to one another in order to face the challenges of the "outside" world. The staff in these houses were not burly psychiatric technicians in white coats, but people interested in growth and development who chose these positions for reasons other than a guaranteed state salary. These halfway houses, while funded through the State, City and County, were run by nonprofit organizations.

Sounds rosy and ideal, doesn't it? But it worked. Part of the reason it worked was that if people became ill again, they could he hospitalized—this time in a psychiatric unit of a local hospital where their families and friends could provide the support essential to recovery. Hospitalizations generally lasted a few weeks in a small, community hospitals as opposed to months or years in the vast impersonal settings of the IMOs. If this was so successful, and it was, what happened? Money.

In 1978, in a so-called taxpayers' revolt, California voters froze property taxes at 1978 levels despite soaring real estate prices. Without tax revenues, state-funded community services such as police, firefighters, schools, libraries and parks, and community health services were depleted. This forced a prioritization of essential services. Mental health services were not considered a priority and these successful programs were defunded.

At that point, all mental ·health care began to be restricted and rationed. When one remembers that mental illness is a brain disease, such rationing is absurd. Throughout the 1980s, community mental health funding diminished and the system devised ever more clever ways for keeping people from accessing services. In 1993, our local mental health system formally announced the policy of rationing services, which it had been practicing for quite some time already. This new policy was called "clustering"; its restrictive "target population criteria" deemed that only those San Franciscans in severe mental health crisis deemed to be a danger to themselves or others would receive services.

From 1993 to 1998, there were more mentally iii people in the California state prison system than in state hospitals. San Quentin's criteria for mental health treatment were less restrictive than the City and County of San Francisco's.

The Mental Health System Today

In 1998, the system has changed, broadening access to the system in order to provide care to more people in less acute states. However, with this broadening of access there is no additional funding, resulting in a classic set up for failure. While more people will be eligible for care, less care will actually be provided. Time will tell which is worse—high levels of care for the very few, or low levels of care for a few more people. Neither strategy, the old cluster system or new managed care, is adequate to provide mental health treatment to the estimated 22,000 San Franciscans who need it.

The Health Commission has passed a resolution accepting "universal access

Figure 52

Seeing Words Design, *Parlor Game: A Popular Version*, Market Street Kiosk poster, central image by **Jane "in Vain" Winkelman,** *Take a Bite Out of America*, 1997, Acrylic Paint on Paper, 1997, Courtesy of Coalition on Homelessness

The Coalition on Homelessness and Seeing Words Design proposed a series of six posters to the San Francisco Arts Commission. Using artwork by several artists from *Street Sheet*, the posters present the six projects of the COH in a series of board games. This poster was for General Assistance Rights Union. The large scale posters were placed in 24 kiosks on Market Street from December 1997 till February 1998.

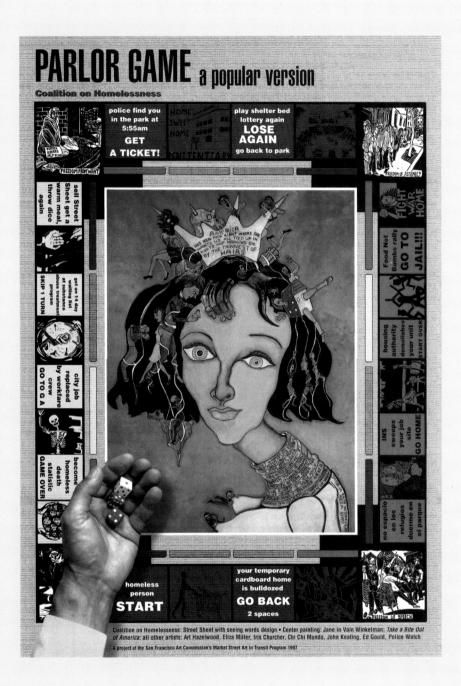

85

to treatment" to provide equal treatment to both those who are ineligible for MediCal and those receiving MediCal. The Department of Public Health is requesting several million dollars of new funding to pay for outpatient treatment and medications for thousands of medically indigent individuals who will now qualify. The budget is now in the Mayor's hands; securing this additional funding will require us to keep the pressure on the Mayor's office. This funding would be a great help, but will come nowhere near meeting the need. What is needed is a complete expansion and rebuilding of the entire mental health system, completed through a thoughtful and complete process with broad community input.

There will be a few hearings in June to demand funding for critically needed mental health services. We will also be meeting with supervisors and conducting outreach to involve large numbers of mental health consumers.

Treatment of people with serious brain disorders has always been driven by funding and fear, and not by the need of the people with the disorders. Until the needs of people, not funding, are placed at the center of the system, the system will fail.

We need a community-based mental health treatment system that not only treats people, but treats people with dignity and respect.

What We Want
What We Demand

• A system of responsive mental health treatment on demand which meets the diverse needs of San Francisco consumers and is driven and designed by mental health consumers.

• A mental health system where individuals may access needed services, when they self-identify as needing them, as opposed to having to wait until they are facing acute crisis.

• A broad community planning process, which involves providers and community workers equally to consumers.

• Monthly forums which give mental health consumers a chance to give input and policy ideas to policy makers.

• A greater understanding by the public of the real needs and issues of psychiatrically disabled and drug addicted individuals.

• Accountable City mental health service bureaucracies.

• SSI advocacy and treatment for every individual with a serious psychiatric disability.

• An independent grievance procedure for mental health consumers.

Street Sheet, November 1998

The Three-Year Itch

• **Agnos Administration, Year 3, campaign mode: police sweeps of homeless people**
• **Jordan Administration, Year 3, campaign mode: police sweeps of homeless people**
• **Brown Administration, Year 3, campaign mode; police sweeps of homeless people**

Is there a trend here?

The Willie Brown administration has spent the last three years doing squat to actually address the root issues of homelessness and poverty in our community. Brown looked on while the Housing Authority demolished hundreds of housing units, and ignored cuts to SSI benefits for the disabled and to family entitlements. And now, like his two predecessors, Brown is kicking off his "re-elect me" campaign year with a massive police program to remove homeless people from sight. There's a definite pattern here: ignore homelessness for three years, then beat the shit out of homeless people.

Three full years into this administration, Brown's homeless coordinator isn't even talking to the Local Homeless Board, which the Mayor and Board of Supervisors created to oversee planning and policy of San Francisco's homeless programs. When the Local Board recently

San Francisco Chronicle

NORTHERN CALIFORNIA'S LARGEST WHOSE PAPER?

★★★★★ EVERYDAY, AD INFINITUM 115 777-1111 NO CENTS (USELESS)

Fuck the Homeless!

SAN FRANCISCO— In his annual Commonwealth Club appearance, Mayor Willie Brown addressed the homeless population that is driving tourists away from our city and destroying our economy: "You have the right to live and die on the streets because it's easier to blame you for your own condition than to admit that our health care system and real estate market is governed by greed — AND you do not generate any profit for us. Besides, you are smelly, scary and you don't vote. You barely know what is happening to you or how to fight it, because you are too consumed by your own illness to advocate for yourself effectively. So, in order to appear like we care, we will change the laws and say that it's for your own good — even though we know that you will not get anymore treatment because of the change in the law — because we are unwilling to fund this for you. And since we have changed the laws, you are now guilty of not being in treatment that does not exist. For breaking the law, you will go to the place that does have room for you—PRISON!"

STAFF *The Chronicle*

Save the Tourists!

Figure 53

San Francisco Print Collective, *Fuck the Homeless! Save the Tourists!*, 2001, Screenprint, 36 x 24", Courtesy of San Francisco Print Collective

This large scale poster showing then Mayor Willie Brown on the cover of the *San Francisco Chronicle* was wheat-pasted in many locations, including in front of the *Chronicle* offices; they were in response to a concerted uptick in laws criminalizing homelessness after vowing to reverse the previous Mayor's anti-homeless Matrix Program.

requested a copy of a homeless plan being drafted by the Mayor's staff, the response was a curtly worded memo stating that the Mayor's office was invoking a deliberative process exemption to the Freedom of Information Act in order to deny access to the plan.

Why would the Mayor's Office be so incredibly arrogant? Mainly because the plan, entitled "San Francisco Cares," really sucks. It goes on for two pages about increased police enforcement and proposes to replace tickets with jail time for people caught sleeping outdoors. It talks at length about shopping cart confiscations, about spending $500,000 to buy a huge tent to shelter people in (which five of his staff went to Santa Monica to see); on the important subject of creating housing for homeless families it allocates no new money and dedicates all of one sentence to the subject, saying the City will reallocate existing federal and state dollars. (There's no mention of the fact the City cannot on its own reallocate funds that are earmarked for specific programs.)

But of course this plan does increase local expenditures in one area: It calls for an increase in staffing (and funding) for the Mayor's Office on Homelessness from four to five full-time staff people. No other Mayor has ever had more than two.

"First, we would redirect our scarce police resources toward a strong street presence aimed at violent offenders,

87

predators and drug dealers. Second, we will reorganize the City's priorities to address the root causes of homelessness: unemployment, too few supportive services for people in need and too little affordable housing for low-income and working people in our City."

Sounds pretty thoughtful and articulate, doesn't it? Well, that quote is from a November 1995 open forum article in the *Chronicle* from then candidate Willie Brown. Now, three years later, the quote fast becomes nothing more than a civics lesson on why so few poor people vote.

The plan that the Local Board asked to see proposes to address homelessness in these ways:

1) Changing the McMillan Drop-in Center, currently a substance-tolerant drop-in center, into a pre-booking holding facility for homeless people picked up by police for allegedly being drunk or disorderly in public;

2) Creating a quasi-court system at Park Station in the Haight Ashbury so that homeless youth could be picked up, tried, convicted and assigned community service hours or detention at the Youth Guidance Center without due process, in less time than it takes to say "Police State." And 3) by December 1998 to have swept all homeless people and any evidence that homelessness exists from the UN Plaza/Civic Center area, then keep bright lights on all night so the police can see if any homeless people try to sneak back in.

How does any of this redirect police resources toward violent offenders, predators or drug dealers? It doesn't.

How does it assist the 1,036 families who have been homeless for the first time this past fiscal year, or the 300 families who found themselves homeless for the second or third time? It doesn't.

How does it assist the over 1,200 people on the City's waiting list for substance abuse treatment or the over 7,000 people with no insurance in need of mental health treatment? It doesn't.

One thing this plan does do, though, is explain why the Mayor's Office on Homelessness and the head of the Mayor's Office on Neighborhood Services, Bevin Dufty, have refused to talk with or share any information with the Local Homeless Board or anyone else. They've refused because they knew we'd tell them that using the police to sweep away homeless people is inhumane to those being swept and ineffective for those who truly work to eradicate homelessness - and that in the past, sweeps didn't even manage to achieve their primary goal: to get Agnos or Jordan re-elected.

Street Sheet, **April 1999**
Laura Ware

Pit Bulls ... and More

The Coalition on Homelessness is often viewed as an aggressive, sometimes antagonistic, and unorthodox group of individuals who are radical in their persistence in implementing systems changes on behalf of homeless and low-income people. What is not so frequently seen or understood is their impressive track record in developing new initiatives, programs, organizations and advisory groups which have contributed substantially to improving the options available to low-income people.

Examples range from the Homework Project (managed by Arriba Juntos, a training program for line staff to increase their skills so they can advance in their organizations) to the Shelter Grievance Procedure (which ensures that all individuals in publicly funded shelters have access to an objective grievance procedure) to the *Street Sheet* (an untempered voice for those who want to speak about the issues of poverty and homelessness) to the Community Housing Partnership (a non-profit housing development corporation whose purpose is to develop permanent, affordable housing with vocational/employment opportunities for homeless individuals and families). In my opinion, the Coalition is one of the hardest working, most effective and persistent organizations in the Bay Area.

The Community Housing Partnership

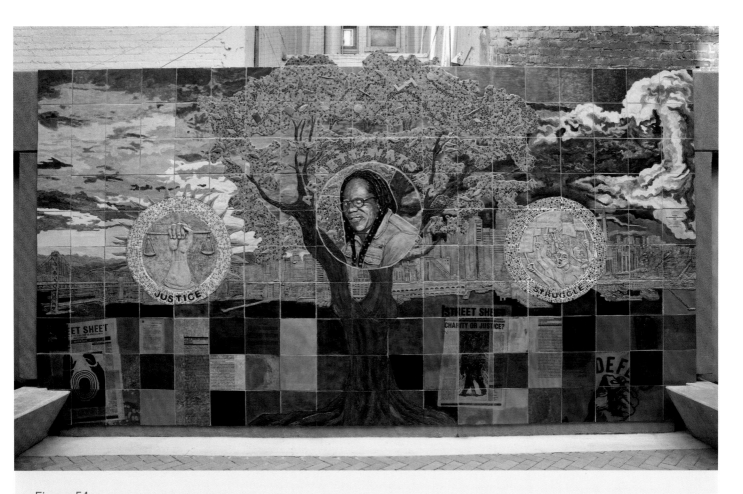

Figure 54

Art Hazelwood & Jos Sances, *Arnett Watson: Justice and Struggle*, 2009, Ceramic Tile and Mosaic, 10 1/2 x 19', Arnett Watson Apartments, San Francisco, Photo Credit: Robert Berger, Artwork Courtesy of the Artists

This ceramic tile and mosaic mural was placed in the courtyard of the Community Housing Partnership building for formerly homeless families. The building was named in honor of Arnett Watson, a long time organizer with the COH. Her work in creating a due process program within the city's shelter system is celebrated as a lasting accomplishment. The mural represents the twin passions of her life, justice and struggle. Placed within the mosaic of leaves in the tree are items referring to her life, including darts and dominoes. Often artwork created for activist struggles is ephemeral. This mural will last as long as the wall it is on stands.

(CHP) was created in 1990 as a collaborative effort of the Coalition on Homelessness (a sponsor in the development of the services, operations procedures and vocational/employment opportunities), and the Council of Community Housing Organizations (a sponsor for the housing development process). Its actual creation and incorporation was an accumulation of two and a half years of development, done in the traditional Coalition workgroup style. This involved convening a large group of homeless and formerly homeless people, service providers, city representatives, business leaders, and members of the general public to diligently develop the basic structures which would become the guiding principles of the CHP. As someone who was fortunate enough to participate in this process, I remember it as an amazing time in which all the parties of the city came together to achieve a common, sensible goal, and that memory has inspired me for nearly nine years.

As a result of this process, the CHP has developed 217 units of housing for families and individuals owned by the CHP and 74 units of housing with services provided by the CHP; a Training Institute which trains up to 20 individuals at a time in the areas of property management, supportive services, administration, supervision and management, and general skills; a Maintenance Work Crew which trains individuals in maintenance skills; and has a staff of 60 of whom 70 are formerly homeless and over 50% are tenants. The method of including diverse groups of people in a development process has proven repeatedly to be a rich experience for the participants, and has developed successful initiatives. This method has also helped create an organizational environment in which tenant input is seen as a crucial perspective which can also lead to future opportunities.

The CHP largely owes its broad base of support to the process described above. The process insists that homeless and formerly homeless people be involved in every aspect of a project (including being decision makers on boards of directors, being paid for their involvement when appropriate). The perspective of the people discussed or served or stereotyped or "case-managed" is included in the basic fibers of all initiatives, and reflects the details which ultimately make it an attractive option to homeless people.

Most importantly, this process demonstrates the power and influence which is present in the ideas, thoughts and voices of homeless and low income people, and the fundamental insight which can only be offered by those who have the experience. I am constantly inspired by the dynamics and persistence of people who have been on the street, and the Coalition stands as a foundation. Yes, the Coalition can be seen as a group of aggressive and pesky advocates, but it can also be seen as an amazing incubator for longterm solutions to the very challenging issue of homelessness. I am honored to know a group of such diverse talents, and I wish them all success in their ongoing efforts.

Street Spirit, April 2006

When the Federal Government Abandoned Affordable Housing, It Abandoned Millions of Americans to Poverty and Homelessness

If we have learned anything about homelessness over the past 25 years, it is that public policy based on assumptions, fear, and paranoia about people forced to live on the streets will never create a plan that can work.

All the recent federal plans on homelessness — FEMA emergency shelter plans, HUD Continuum of Care plans, and the 10-year plans of the Bush administration's Interagency Council on Homelessness — are based on the assumption that in the early 1980s, homelessness reemerged in America because something was wrong with the people who were becoming homeless.

The federal government required local communities to submit competitive applications for federal largesse, and to show that they could effectively address the "problems of homelessness in America" within the grant amounts allocated. So local governments did just that: they formed committees, created task forces, hired tons of consultants, and they wrote grant after grant and plan after plan stating how they were going

Figure 55
Street Spirit, July 2009, cover art: clockwise, artwork by **Eric Drooker, Sandow Birk, Nili Yosha,** from the touring exhibition *Hobos to Street People: Artists' Responses to Homelessness From the New Deal to the Present,* Courtesy of Street Spirit

In 1995, Terry Messman working with the American Friends Service Committee contacted the COH about creating an East Bay *Street Sheet*. The Coalition gave advice in creating a separate paper–*Street Spirit*–that would be grounded in the East Bay community.

STREET SPIRIT

Volume 16, No. 07 **July 2010** $1.⁰⁰

A publication of the American Friends Service Committee

JUSTICE NEWS & HOMELESS BLUES IN THE BAY AREA

Artists Respond to Homelessness from the Depression to the Present

"The Hand That Takes" Artwork by Eric Drooker

ARTISTS AND SOCIAL JUSTICE

This special art issue of *Street Spirit* displays an anthology of artworks on the issues of homelessness, poverty and social justice. This issue compiles the best articles on art and justice to appear in *Street Spirit* from 2006 to 2010.

"GI Homecoming" Sandow Birk, Oil on Canvas

"Homeless Go Home" [Segregation, After Norman Rockwell] Art by Nili Yosha

by Carol Harvey

Terry "Tresa" Chandler stood in the vaulted art gallery. Her tiny 4-foot-11-inch figure was dwarfed by the colorful painting of a Latino child walking to school past a rotten tomato splashed against graffiti on a wall, ordering "Homeless Go Home."

The child is protected by four adults as he walks to a school for homeless children. Artist Nili Yosha crafted the work after Norman Rockwell's illustration of guards escorting a small black girl into a newly integrated Little Rock school in the civil rights era.

Chandler tilted her head, peering at me with a shy, sardonic smile. "When people say this," she observed, "they are doing it to be mean. It's good that homeless people get to see (this show) too. Then we can tell you if it's real or not. The best thing about this show is it makes people think." Chandler's voice echoed slightly, "I live it.

It's so real. All this is so true."

I invited four formerly or presently unhoused San Franciscans to The California Historical Society at 678 Mission Street in San Francisco. They viewed a collection of paintings, prints, photographs, and mixed media pieces by more than 40 artists in an exhibition entitled "Hobos to Street People: Artists' Responses to Homelessness from the New Deal to the Present."

The show was on display from February 19 to August 15, 2009. It was organized by curator Art Hazelwood, a San Francisco artist whose artworks on homelessness and social justice are often published by *Street Spirit*, and the Western Regional Advocacy Project (WRAP).

Charming, well-spoken Chandler, 27, once slept in nearby Annie Alley next to a dumpster pictured in an exhibit photo. After one night on the street restlessly avoiding dangerous biting rats, Eric Robinson, 54,

See **Hobos to Street People** *page 10*

to address the problem if only the feds would give them the lion's share of the money.

Plans deemed groundbreaking and effective changed over the years as the "dysfunctional homeless sub-group of the month" changed. But one thing was always constant: the root of the "problem" was blamed on homeless people, not on the federal government. After all, it was the federal government – not the homeless people – evaluating the proposals.

The federal government pretended – and legions of nonprofits and city agencies applying for federal grants were forced to believe – that the $54 billion reduction in affordable housing funding over the last 25 years could now easily be addressed with life-skills training for homeless single mothers.

The federal government promulgated the myth that its tax credits for companies to send blue-collar jobs overseas could be easily offset by having welfare recipients sweep streets and pick up garbage in exchange for below-poverty-level welfare assistance so that they will value "giving back" to the community.

Imagine this: Suppose it wasn't the federal government evaluating these proposals to address homelessness. Let's say it was your high school science teacher. The average high school science teacher could, in a few hours, shred the flawed assumptions, half-baked hypotheses, and

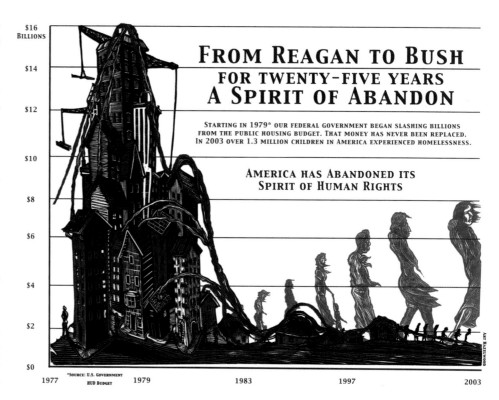

Figure 56
Art Hazelwood, *A Spirit of Abandon,* 2006, Digital Print, 18 x 24", Courtesy of WRAP

lack of factual evidence that comprise these weighty and endless volumes of governmental plans.

Therefore, in honor of high school science teachers across America, we present you with some facts to ·consider the next time you' re wondering, "Where the hell did all these homeless people come from?" Look for the common denominator amongst all these people. If we can identify that, we can begin to make some assumptions and perhaps come up with

a hypothesis about the causes of and potential solutions to "the problem" of homelessness.

Our government has formed a flawed hypothesis about homelessness because, from the very outset, it has conveniently turned a blind eye to its own role in drastically cutting federal housing funds.

Instead of looking honestly at the factors that created an enormous shortfall of affordable housing, our government

simply jumped to an unscientific pre-judgment of homeless people themselves and set out to "fix" them with counseling and micromanagement instead of addressing the nation's calamitous housing shortage.

Fact one: Compared to 1978, the U.S. government is now spending nearly 65 percent less on developing and maintaining affordable housing for poor people. ($83 billion was appropriated in 1978, while only $29 billion was allocated in 2005.)

Fact two: Compared to 1978, the U.S. government now spends $84 billion more on subsidies for homeownership programs. (It spent $38 billion in 1978 on these subsidies for middle-class and affluent homeowners versus $122 billion in 2005.)

Fact three: In 2004, 61 percent of all federal housing subsidies went to households earning over $54,787 per year, while only 20 percent of those subsidies went to households earning less than $18,465 annually. The 2004 federal poverty threshold for a household of four with two minor children was $19,157.

Hypothesis: There is a direct correlation between the fact that, in the late 1970s, the U.S. government made a conscious decision to redirect expenditures for housing from rental assistance for poor people to homeownership, and the re-emergence of homelessness in America in the early 1980s. When President Reagan "reinvented government" by drasti-cally slashing assistance to the poorest of the poor, he played a major role in reinventing homelessness so that it re-emerged in modern America.

If our federally mandated housing and homelessness plans (FEMA, HUD and ICH) and our locally politicized campaigns had been focused on address-ing "what created this mess" in the first place, the ludicrous current attempts to fill a $54 billion housing hole with a mere $1.37 billion of annual homelessness assistance funding would have drawn ridicule long ago.

How many life-skills training courses would a homeless person need to take to compensate for the fact that, in the 20 years from 1983 to 2002, the U.S. government built 500,000 fewer units of affordable housing than it did in the seven years from 1976-1982? How many money-management classes must a rural parent take to compensate for the 35,000 fewer units being built in rural America each year?

Are money-management classes and life-skills training good things? Sure, why not? Is a lack of money-management classes and life-skills training the cause of our nation's massive re-emergence of homelessness? Doubtful. Will money management and life-skills training –or case management, or more outreach, or the repressive policing of homeless people for sleeping and living on our streets –ever create enough housing to make up for a $54 billion cutback from the federal government? Hell no.

If we want to address homelessness in America, we need to stop looking at "them" and start looking at us. If we believe our government represents us, it is we, the people, who must force the federal government to create justice. What did we (the U.S.) do to contribute to this problem and what can we (the U.S.) do to address it?

Acting in our name, the U.S. government has chosen to redirect our housing subsidies to homeownership; the real estate industry receives over $120 billion dollars a year towards this goal. Acting in our name, the U.S. government has chosen to cut $54 billion from housing assistance programs for poor people. We (as citizens of the U.S.) know that 1.3 million children experienced homelessness in 2003.

Look at the information we present to you. Not only do the facts invalidate the current housing "plan" of the federal government, they invalidate their underlying hypothesis. A group of us - Western Regional Advocacy Project (WRAP) have gathered documented data from the U.S. government about its housing policies. We have converted this information, facts if you will, into easily understandable charts. Charts can give the same information in a direct visual way that more people can digest and understand. They also do a hell of a good job at cutting through the lies and misinformation of politicians and showing the

real trends in our nation's housing policies.

When this nation first abandoned its commitment to funding federal housing programs, it abandoned millions of homeless people with the same stroke. Abandoned federal housing programs led directly to millions of abandoned, impoverished Americans languishing without housing in cities across the nation. Something else that is just as precious to our national identity has also been abandoned: the very spirit of human rights has been left by the wayside to die of the same neglect and callous disregard.

Trends tend to reflect priorities and, after three years of studying these trends, we at WRAP feel it is the right time for us to make a hypothesis. Our educated guess, or hypothesis, is that an equal distribution of housing subsidies from the federal government will have a dramatic impact on alleviating homelessness in America.

We also have a related hypothesis: that an honest evaluation of corporate welfare vs. citizen's welfare will show that our government urgently needs to balance out who is getting government help before our government decides who needs life skills training. We, the people, must stay focused, not on promoting the corporate "bottom line," but on promoting "the common welfare," as it says in the preamble to the U.S. Constitution.

WRAP 2009

The Perception of Safety

Fear can motivate people to do some really strange things. From guns under the pillow to bars on the window to living in gated communities, fear has long been a motivator recognized as one emotion that can move masses of people to do things they would normally never consider. Certainly the current proliferation of "nuisance crime laws" and private security (or ambassadors) in public spaces is a manifestation of people's fears that after 27 years growing poverty and homelessness is becoming impossible to ignore. Unfortunately, adding to the litany of camping, loitering, trespassing, blocking the sidewalk and panhandling laws isn't going to change a damn thing. They haven't so far and we all know what they say about stupid.

People are rightfully nervous these days. Unemployment is at a level not seen since the depression, foreclosure rates continue to rise despite the massive bailouts to banks and lenders, seems almost everyday another factory is closing or laying off much of the workers. Local and State governments across the country are cutting programs, privatizing parks and other municipal services, raising fees for permits, fines and tuitions and putting government workers on furloughs, early retirement, reduced hours or lay offs, all in response to budget deficits that in many States are now in the billions of dollars.

Figure 57
San Francisco Print Collective, *Invest in Us,* 2009, Screenprint, 25 1/4 x 18 3/4", Courtesy of San Francisco Print Collective

A reworking of a poster for the 1930s WPA Federal Theater Project. The original poster advertised *One Third of a Nation,* a play ,about housing speculation and the lack of affordable housing in the Great Depression. This poster advertises a June 2009 protest organized by the COH in defense of spending on basic city services.

Figure 58 (inset)
Coalition on Homelessness protest 2009, Photograph, Courtesy of Coalition on Homelessness

"When the US ran up against the Great Depression-the worst economic catastrophe the country had ever seen—our society survived by investing in our people and creating the programs that led to public housing, SSI and Food Stamps. Join us to push San Francisco's government to make the right choices in hard economic times and to invest in the endangered programs that serve us all and save our most vulnerable neighbors."

-excerpt from *Street Sheet,* June, 2009

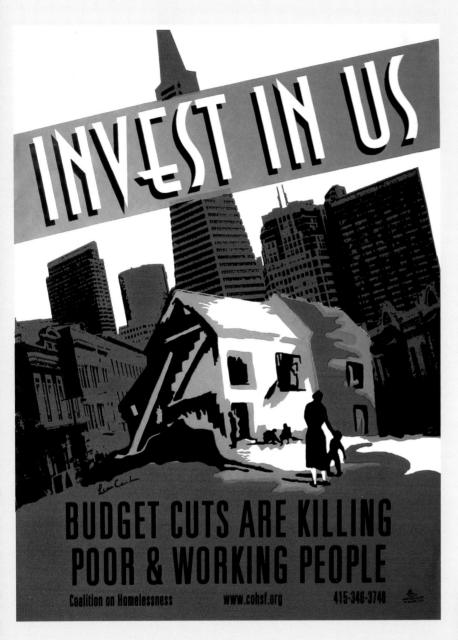

INVEST IN US

BUDGET CUTS ARE KILLING POOR & WORKING PEOPLE

Coalition on Homelessness www.cohsf.org 415-346-3740

Every night on the news are stories of people and families who never in their lives thought they would eat at a soup kitchen, get food from a pantry or sleep in a shelter lined up alongside others who are now being referred to as the "regular homeless." Newspaper headlines blare out about the rising numbers of homeless children in public schools, social service programs, seeing their charitable giving dramatically reduced because of the recession and amazingly, in town after town and city after city new laws being proposed to mitigate the impact of growing poverty and homelessness on the rest of "us," as in those who still have a job, business or home.

The whole concept of the debate is false: Business Improvement Associations (BIDs) have model legislation that they

95

work with local members, governments and police to see adopted, complete with talking points and media plans. Whether the focus of each particular law is panhandling, feeding, sleeping, loitering or the current fad of sitting and lying, the premise behind every campaign is the same: people don't feel safe and it is the presence of all these poor people that are making us feel this way.

The perception that (your city here) could be seen as being tolerant of poor people being visible means tourists will stay away, families outside the city won't come downtown to shop, small business will go under, taxes can't be collected by government, budget deficits will increase, more services will be cut and fees raised, which will mean more people will become poor and homeless which will lead to more people being visibly destitute which will destroy our quality of life and cause people to feel even less safe.

This argument has worked surprisingly well with the mainstream media and local legislative bodies. It has a certain cause and provides a specific answer. The cause is "these people" and the answer is to get rid of them with the Neo-Liberal kicker that this is all for the greater good. Politics 101…find someone to blame and pound the message home till it becomes its own reality.

The fear and nervousness is very real BUT solutions do exist…. A new New Deal, a human right to housing, education and treatment, a true living wage - any of these approaches will prove much more effective in the long run. People on both sides of the debate seem to agree on this but the criminal enforcement advocates keep demanding "action now." For 25 years "action now" has meant needing even more action tomorrow. The actions we're taking are equivalent to painting over the stain caused by a leaky pipe, 5 minutes of satisfaction for a job well done and then getting wet all over again. If the current situation on our nation's streets was simply an issue of a lack of laws, they would have existed long before the mid 1980s.

If we as a nation had initially diagnosed emerging homelessness in the early 1980s as a "busted drain pipe" in our efforts to address poverty instead of a temporary crisis for dysfunctional people, the divisiveness, hostility and anger that surrounds today's "action now" campaigns would be virtually non-existent because the fear this all stems from would be so much less.

Local governments can continue to pass all the anti-sitting, anti-feeding, anti-camping and anti-panhandling laws they want. They can continue with curfews in our public parks and turning over our downtown neighborhoods to Business Improvement Districts, but the drain pipe is still leaking and the water level continues to rise. We all know we're going to have to address it at some point and we're running out of paint.

Paul Boden blog at Huffington Post 09/21/2012

This Crow Won't Fly

The United States has a long history of using mean-spirited and often brutal laws to keep "certain" people out of public spaces and out of public consciousness. Jim Crow laws segregated the South after the Civil War and Sundown Towns forced people to leave town before the sun set. The anti-Okie law of 1930s California forbade poor Dustbowl immigrants from entering the state and Ugly Laws (on the books in Chicago until the 1970s) swept the country and criminalized people with disabilities for allowing themselves to be seen in public. Today, such laws target mostly homeless people and are commonly called "quality of life" or "nuisance crimes." They criminalize sleeping, standing, sitting, and even food-sharing. Just like the laws from our past, they deny people their right to exist in local communities.

In June of this year, Rhode Island took a meaningful stand against this criminalization and passed the first statewide Homeless Bill of Rights in the country. The Western Regional Advocacy Project (WRAP)–a West Coast grassroots network of homeless people's organizations –is now launching simultaneous campaigns in California and Oregon. Rhode Island will only be the beginning.

Figure 59
Ronnie Goodman, *No More Homeless Deaths*, 2011, Linocut Print, 24 x 18", Courtesy of the Artist

This print was inspired by Adelyne Cross Eriksson's 1940 print commemorating the 1934 General Strike in San Francisco. It shows crowds marching down Market Street with the coffins of the murdered dock workers. Here Goodman envisions that solidarity as a tide of people protesting the death of homeless people. The border images refer to the rats, bedbugs and biohazard symbols that homeless people live with on the street.

Today's "quality of life" laws and ordinances have their roots in the broken-windows theory. This theory holds that one poor person in a neighborhood is like a first un-repaired broken window and if the "window" is not immediately fixed or removed, it is a signal that no one cares, disorder will flourish, and the community will go to hell in a hand basket.

For this theory to make sense, you first have to step away from thinking of people, or at least poor people, as human beings. You need to objectify them. You need to see them as dusty broken windows in a vacant building. That is why we now have Business Improvement Districts (BIDs) with police enforcement to keep that neighborhood flourishing by keeping poor, unsightly people out of it.

We have gone from the days where people could be told "you can't sit at this lunch counter" to being told "you can't sit on this sidewalk," from "don't let the sun set on you here" to "this public park closes at dusk" and from "you're on the wrong side of the tracks" to "it is illegal to hang out" on this street or corner.

Unless we organize, it isn't going to get much better soon. Since 1982, the federal government has cut up to $52 billion a year from affordable housing and pushed hundreds of thousands of people into the shelter system or into the street. Today we continue to have three million

people a year without homes. 1982 also marked the beginning of homelessness as a "crime wave" that would consume the efforts of local and state police forces over the next three decades. Millions of people across the country sitting, lying down, hanging out, and -- perhaps worst of all - sleeping are cited in crime statistics.

WRAP and our allies recently conducted outreach to over 700 homeless people in 13 cities; we found 77% of people had been arrested, cited, or harassed for sleeping, 75% for loitering, and 73% for sitting on a sidewalk.

We are right back to Jim Crow Laws, Sundown Towns, Ugly Laws and Anti-Okie Laws, local laws that profess to "uphold the locally accepted obligations of civility." Such laws have always been used by people in power against those on the outside. In other words, today's Business Improvement Districts and Broken Window Laws are, at their core, a reincarnation of various phases of American history none of us are proud of.

And they reflect a political voice now openly entering the political and media mainstream that dismisses social justice as economically irrelevant and poor people as humanly irrelevant.

This is not about caring for or even advocating for "those people." This is about all of us. As Aboriginal leader Lilla Watson said, "If you have come here to

help me, you are wasting your time. But if you have come because your liberation is bound up with mine, then let us work together." If you are not homeless, if you are not the target now, then understand that you are next. Isolated and fragmented, we lose this fight.

We can only win this struggle if we use our collective strengths, organizing, outreach, research, public education, artwork, and direct actions. We are continuing to expand our network of organizations and cities and we will ultimately bring down the whole oppressive system of policing poverty and treating poor people as "broken windows" to be discarded and replaced.

Figure 60
Art Hazelwood, *People over Profits*, 2012, Screenprint, 24 1/2 x 15 1/2", Courtesy of the Artist

Created originally as an image for the Occupy Movement, WRAP adopted this poster to give vision to the overturning of the power of elites by the power of people. The triumvirate below control chess pieces on their geopolitical board but they have been overturned by the people seizing power in the capitol building.

McKinney-Vento turns 25 and homelessness continues to grow!

Passed in 1987, this federal program was intended to address the emergency needs of homeless people while the federal government worked to restore the funding which had been cut from HUD's affordable housing programs.

But it didn't work that way. McKinney-Vento has spawned an endless array of continuum of care plans, 5-year plans, 10-year plans – an endless system of writing, planning, researching which "best practices" should be used to end homelessness while at the same time the federal government has continued to defund, dismantle, and sell-off affordable housing units, thus ensuring that more and more people become homeless. 360,000 Section 8 and 210,00 Public Housing units lost since 1995.

It is a shameful trade that robs Peter to pay Paul.

McKinney homeless assistance programs have increasingly become a catch-all system for people who were once permanently housed by mainstream federal programs such as HUD and USDA. Yet even as affordable housing has been decimated (over 800,000 units lost in 25 years), eligibility criteria for McKinney-Vento homeless assistance have been tightened.

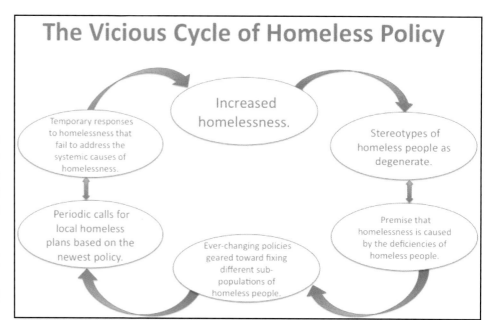

Figure 61

And to add insult to injury, we are seeing a massive PR campaign by federal agencies such as HUD and the Interagency Council on Homelessness to convince everyone, or perhaps to convince themselves, that with just the right coordination, facilitation, and cooperation, they will actually end homelessness. This is self-deception. Anyone who has done the math would know. The ongoing new guidelines, new initiatives, newly named target populations suggest that people overseeing this system clearly know it's not working.

To provide a context: in the 25 years since McKinney passed in July 1987, two major events severely impacted the numbers of poor people finding themselves homeless.

The first was the 1998 Contract with America during the Clinton Administration when the Housing Act of 1937 was changed from "remedy… acute shortage of decent, safe and sanitary dwellings" to declaring that "the federal government cannot … provide housing of every American, or even the majority of its citizens."

The second was in 2009, the last time McKinney-Vento was reauthorized in Congress. Renamed the HEARTH Act, it instructed HUD to create a new bureaucratic definition of who is homeless. By implicitly admitting defeat that the McKinney-Vento model has any chance of stopping the growing wave of homeless people, the Hearth act instead redefines "homelessness" out

of existence for thousands of families and people without homes. A 105-page HUD memorandum describes who is homeless and establishes welfare-oriented criteria that determine who will qualify. It is particularly hard on families who live doubled up, tripled up or in SROs.

Advocate Organizations – be they local, statewide or national -- that continue to focus on McKinney-Vento will never be catalysts of the change we need. Their funding is too contingent upon being seen as legitimate by whatever administration is in power, a dependence that moves those in power even further away from the actual lives and experiences of poor and homeless people.

Consulting and research firms have probably benefited the most from McKinney-Vento funding because HUD bureaucrats like justifying their proposals by paying researchers. We need no further consulting or research to understand the direct and obvious correlation between massive affordable housing cuts since 1978, the opening of emergency shelters in the early 80s, and the continued and growing existence of homelessness today.

In 2006 and updated in 2010, WRAP issued a carefully researched analysis on the systemic causes of homelessness. Other studies and research done on homelessness must have been able to gather the same information. Had they looked closely at the underlying cause and effect issues connected with massive numbers of people without housing, they should have been able to connect the dots. But they seem not to have looked. It's not a difficult correlation, but the dots have been left unconnected.

We need to be honest: too many organizations or departments, in and out of government, turn away from the simple connection between the absence of affordable housing (cause) and the increasing numbers of homeless people (effect). No amount of coordination or redefinition is going to end homelessness. McKinney-Vento was created to address the effects of homelessness and it is time for HUD and USDA to step up and address the cause of homelessness.

If the past 25 years have taught us anything at all, it is that nothing ends homelessness like a home.

Paul Boden and the history of homelessness as we know it today

We recently sat down with Paul Boden to talk about modern day homelessness and the history of the criminalization of people on the streets.

Israel Bayer: *Let's start at square one. How did we get to a place of modern day homelessness?*

Paul Boden: It's pretty simple, when you look at it as cause and effect. We started out in 1979 with deep cuts to our affordable housing programs. It was the last year of (President Jimmy) Carter; it was the recession, it was the hostage crisis in Iran; and Carter did across-the-board cuts to all of the federal programs. (President Ronald) Reagan came in 1980 with a strong base of support across the neo-liberal economic folks out of the Chicago School of Economics. His revolution was to bring that practice of governance and of priority-setting to the United States government. We did it in the "Banana Republic" countries of South America and Central America. We knew how to implement it, and it became the standard. It still is the standard of how priorities get set at the federal level.

Between 1979 and 1983 we saw $54 billion a year in cuts to affordable housing. By the winter of 1982, we were opening up emergency shelter programs across the country at a rate we had not seen since the Great Depression. Here we are now, 30 years later.

When you look at it from a global perspective, what you notice is, the funding was never restored. You can't continue to decimate financial support systems when housing is a commodity and not think that people without the financial means aren't going to suffer from it. You just can't do it. And clearly, we are doing it.

The consequence of these policies is massive numbers of people from all different geographic and educational backgrounds — with all different skin colors, single adults, gay kids, straight kids, families — end up homeless. Across the spectrum, we see people ending up without housing. We keep reinventing the wheels of public planning processes and federal priorities, thinking if we can just hit this one magic pill, then we'll fix it without looking at what we've created. I think it's a classic example of cause and effect and connecting the dots, and going back to, when did the housing crisis start, what happened right before it started, and let's see if that wasn't the primary cause of it. Granted, people will say, "Housing isn't the only reason people are homeless." Well, frankly, mental illness existed before 1983. Sexual abuse existed before, and sure as hell poverty and racism ex-

isted. So, when you talk about homelessness, not all of the other social justice issues, but the issue of people living without housing, I don't see how you can disregard the dramatic impact and effect that these massive federal cuts had on the living conditions of people in local communities.

I.B.: *How has the lack of federal funding affected local communities in tackling the issues of homelessness and housing?*

P.B.: It has divided and conquered a hell of a lot of them.

The 10-year plan to end homelessness was going to end homelessness. The five-year plans during the Clinton Administration were going to end it before that.

The public gets this messaging about homelessness initiatives, but across the country, 10-year plans are 12 years old. The situation, for families especially, is worse.

You have this disinformation in order to make local governments feel like we are addressing the problem, or at the very least giving the pretense that they are addressing it. The public receives these messages through the newspaper, on the radio, and on TV, so it must be true.

When these plans fail to achieve their goals, the public begins to think that people experiencing homelessness must be dysfunctional. We have really reinforced that it's their alcoholism, or mental health, their laziness, their sloth, their viciousness, they're sexual predators.

They are other than us. Which is where the criminalization of homelessness comes into play.

The one thing we seem to have no shortage of funding for is jail, police, and security. You create an '"Us vs. Them" atmosphere and then the answer is to get rid of them. To make homeless people disappear.

The problem that they're finding (and this was true in the Depression era with the Anti-Okie laws and Sundown Towns) is that if you're not stopping the floodgates of people that are ending up on the street, your policing of them becomes never ending.

I.B.: *How do you think we can combat that? What can local government, advocates, and communities do?*

P.B.: All of us that are participating in the ten-year planning processes and in the local homeless coordinating boards and in the delivery of services from the funding that is available, we should all stop and say, 'You know what? We don't just need more hollowed out homeless plans. We need federal funding for affordable housing'.

It took local communities doing organizing that created what we now call HUD in the first place. That wasn't that long ago, it was 1937. That's within one generation. It was created because government was forced to respond to the needs of local communities.

We need to elect local representatives that will fight with the government on

Figure 62
Art Hazelwood, *Change the Priorities*, 2013, Offset Print, 17 x 11", Courtesy of WRAP

WRAP uses this poster based on data from *Without Housing* showing the massive discrepancy in federal funding priorities. Ten fewer planes among the thousands in our arsenal and we could double affordable housing funding.

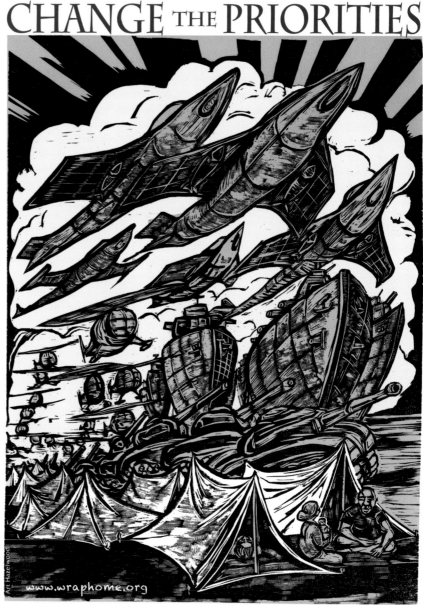

our behalf and then get them elected to the federal level once they do it. We have a poster from 1936 where the Mayor of New York had images of homelessness that said, 'Must we always have this?' Now the Mayor of New York is touting broken windows and hiring guards to patrol subways to make sure there are no fare evaders, but primarily to make sure there are no homeless people sleeping on the subways.

Is the Mayor of New York honestly pushing for the restoration of this funding? No. And back in 1936 mayors were pushing to create state and federal programs to support housing.

We can't sit around and think that Obama's going to fix it; it's not going to come from the sky. It has to come from the community that says these are rights that we're equally entitled to. Why would you not want a government that says housing, healthcare and education are values that we all are entitled? We have no problem with businesses making a profit, that's a significant priority within government. If there's no profit for any corporation in the equation with our public parks, schools, housing system, healthcare system, it's not a priority for our government. A perfect example of this on the issue of housing is the mortgage interest reduction action programs that spend more than $140 billion a year.

I.B.: *Let's talk about the housing mortgage interest reduction program.*

P.B.: It's where you borrow money to buy a house, you pay interest on the money that you borrowed, and then you're able to write a percentage of that interest off on your taxes that you pay to state and local government. It is a subsidy from the government for the fact that you are purchasing housing. Rentals have nothing similar in place.

We've wiped out the subsidies for rental properties to poor people. What little is left is screened on moral grounds, and whether the government can afford it. On the economic stimulus side of things, there's no cap. It comes down to collecting money versus allocating money.

The bottom line is, if you owe me $50 and I tell you to keep it, I just gave you $50. From a simple math perspective, money not collected is the same as money spent. In a political realm, money not collected is a stimulus. The money's going to mortgage interest companies, to banks, to realtors, to construction companies. When the money's going to poor people, it's charity, it's welfare, and we have to limit it.

We do $34 billion in affordable housing funding for poor people and we screen the hell out of who's eligible for it. We complain about it all the time, and we set up systems for oversight for review that would put the IRS to shame.

We do $144 billion in subsidy for homeowners and we call it "Economic Stimulus" and we put no cap on it whatsoever. The government didn't stop investing in housing. It stopped investing in housing that applied to poor people.

I.B.: *Talk to us about the history of the criminalization of the poor in the United States.*

P.B.: In doing the research, we discovered about a 40-year pattern of laws tailored to local communities targeting the same group, going back to the 1860s, and with the alms houses in England, going back even before that.

In the 1860s, San Francisco created what they called "ugly laws," and they swept the country. Basically, the laws say that maimed, diseased or mutilated panhandlers needed to be swept off the street. Then you had the "Sundown Towns," the Japanese Exclusion Act, you had Jim Crow. There's this pattern of local governments seeing this social and/or economic issue they're freaking out about and saying, "I can't fix this, so I'm going to get rid of it."

If local communities can't address the underlying causes for a social program due to the lack of resources or political will they eventually begin to use their legal authority to create laws to try to solve the problem.

It's usually followed by well-crafted public relations campaigns targeted at the media to make the general population scared of homeless people. What better way to sell newspapers than to dehumanize people? You use fear to instill in people a desire to make "it" go away. Everybody hates the boogeyman. You turn the squeegee guys in New York into the boogeyman, no one's going to complain when they disappear, or ask where they go, because they don't care where they went.

Figure 63
Housing is a Human Right, 2013, Collage of Photographs by **Francisco Dominguez,** 2009, *Housing Not Handcuffs*, Sacramento, CA, **Dorothea Lange,** 1937, *Scene Along "Skid Row"*, San Francisco, Courtesy of WRAP

Two photographs from the Great Depression and today point to the ongoing struggle to gain acknowledgement that poverty is a human rights issue.

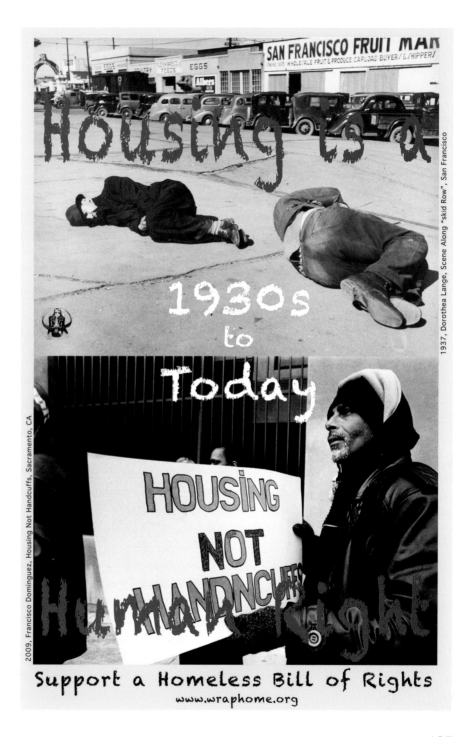

When we looked at movie trailers from the 1930s and 40s, it was exactly how they were justifying Anti-Okie Laws. American citizens traveling across the country in search of something better were often times portrayed as rapists or felons. The message was, "We need to protect ourselves by making these people from Oklahoma go away or not letting them into California."

If you look at the quality of life enforcement programs — they say people can't sit, or stand still or lie down. They say in certain circumstances you can't eat or sleep. Well then, if I don't have a home, what the fuck can I do? Walk.

The irony is, while we call these offenses "crimes," every human being has to be engaged in these activities to simply survive.

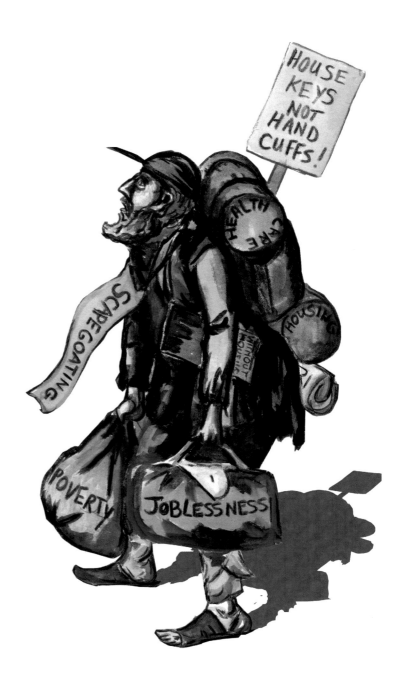

Figure 64 (left)
Art Hazelwood, *Scapegoat*, 2009, Watercolor, Courtesy of the Artist

Figure 65 (right)
Photographer Unknown, *Homeless Caucus March*, 1983, Photograph

Thank you to the following contributors whose work appears in this book.

Artists:
Sandow Birk, Robert Curet, Joseph DeNeri, Francisco Dominguez, Eric Drooker, Ronnie Goodman, Ed Gould, Christine Hanlon, Art Hazelwood, Dorothea Lange, Allison Lum, Tom McCarthy, Malcolm McClay, Eliza Miller, Doug Minkler, Maxx Newman, Jos Sances, Tony Taliaferro, Jane "in Vain" Winkelman, Nili Yosha

Artist Collectives:
Paula, Jennifer and John from Odiorne Wilde Narraway and Partners, San Francisco Print Collective, Sit/Lie Posse, Seeing Words Design

Writers:
Israel Bayer, Laura Ware

And all the *Street Sheet* and WRAP writers, artists and photographers that didn't use bylines.

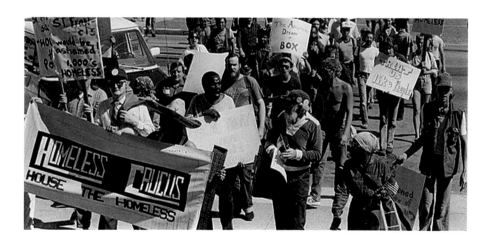

FREEDOM VOICES